W9-ANZ-534

MACROPHOTOGRAPHY
Capture Larger-Than-Life Photographs of Nature's Smallest Subjects

DENNIS QUINN

AMHERST MEDIA, INC. ■ BUFFALO, NY

Acknowledgments

I would like to thank the Connecticut Department of Energy and Environmental Protection for their consent and support in my endeavors to photographically document various protected species in Connecticut. Dr. Michael W. Klemens and Melanie Bachman for unrestricted access to their beautiful Connecticut properties, a nature photographer's dream. Laurie Klein for her expert comments and unwavering support of my photography career. Jessica Marshall for text review and editorial comment. Erin Manion, consulting graphic designer, for her digital reconstructions of lighting diagrams and subject staging. William Moorhead, consulting botanist, for his assistance with the identification of select flower species. Joseph A. Rizzo for his technical assistance in the construction of aquatic rearing tanks for various amphibian larvae. Len Rizzo Jr. for technical lighting assistance. Nicole Cudzilo for not only her tireless contributions in postproduction of images, editorial review, comments, and overall conceptual framework—but for me, most importantly, being the most influential person in my photography career. Nicole has always been my unwavering supporter, teacher, and technical critic, encouraging my photography even during times when I've contemplated putting the camera down. For that, I owe her my deepest gratitude and thanks. And, finally, my parents for their continued support and encouragement in all my lifelong endeavors. Raising a herpetologist comes with a unique set of challenges and they couldn't have done a better job. There is no greater gift in life than parents with unwavering love, encouragement and support. Thanks, Mom and Dad.

Copyright © 2016 by Dennis Quinn.
All rights reserved.
All photographs by the author unless otherwise noted.
Author photograph by Nicole Cudzilo.

Published by:
Amherst Media, Inc., P.O. Box 538, Buffalo, N.Y. 14213
www.AmherstMedia.com

Publisher: Craig Alesse
Senior Editor/Production Manager: Michelle Perkins
Editors: Barbara A. Lynch-Johnt, Beth Alesse
Associate Publisher: Kate Neaverth
Acquisitions Editor: Harvey Goldstein
Editorial Assistance from: Carey A. Miller, Sally Jarzab, John S. Loder
Business Manager: Adam Richards

ISBN-13: 978-1-68203-076-9
Library of Congress Control Number: 2016931526
Printed in The United States of America.
10 9 8 7 6 5 4 3 2 1

No part of this publication may be reproduced, stored, or transmitted in any form or by any means, electronic, mechanical, photocopied, recorded or otherwise, without prior written consent from the publisher.

Notice of Disclaimer: The information contained in this book is based on the author's experience and opinions. The author and publisher will not be held liable for the use or misuse of the information in this book.

www.facebook.com/AmherstMediaInc
www.youtube.com/c/AmherstMedia
www.twitter.com/AmherstMedia

AUTHOR A BOOK WITH AMHERST MEDIA!

Are you an accomplished photographer with devoted fans? Consider authoring a book with us and share your quality images and wisdom with your fans. It's a great way to build your business and brand through a high-quality, full-color printed book sold worldwide. Our experienced team makes it easy and rewarding for each book sold—no cost to you. E-mail submissions@amherstmedia.com today!

Contents

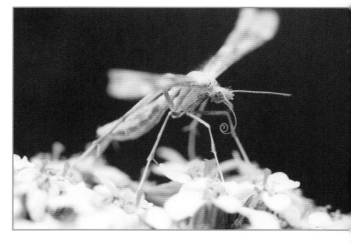

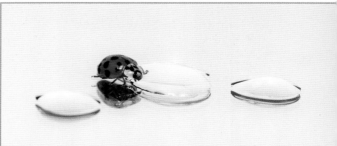

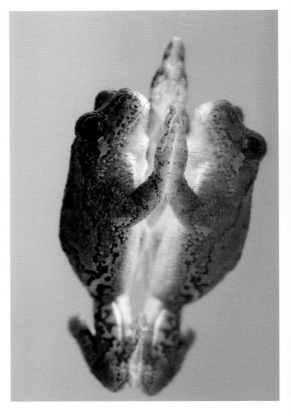

About the Author

Dennis Quinn is a Connecticut native who grew up just outside the city limits of New Haven. His interest in the natural world stems back to his early childhood days, when he spent much of his time observing wildlife in the field.

Dennis earned a Master of Arts degree from Central Connecticut State University in Ecology and Environmental Science and shortly thereafter founded an environmental consulting firm (CTHerpConsultant, LLC) that specializes in amphibian and reptile research, conservation, and preservation.

He is active in environmental education through his Adjunct Instructor position at Naugatuck Valley Community College, where he teaches General Zoology and Field Biology.

Combining his scientific career with photography, Dennis also created www.ctherpetology.com, a website that serves as a photographic atlas for the identification of Connecticut's amphibians and reptiles. Capturing images that ignited interest and questions from viewers, Dennis quickly realized the value of photography in his pursuits of conservation, and now shoots the macro-world to shed light on the astounding species diversity that surrounds our daily life.

Dennis actively displays his photographs in galleries, nature centers, and art festivals and has been published in various wildlife magazines, newspapers, educational pamphlets, and scientific documents. He is active on social media and has won image awards in online gallery contests.

1. Timing Is Everything
17-Year Periodical Cicada ■ *Magicicada septendecim*

As its name suggests, the 17-year periodical cicada emerges only once every 17 years. Therefore, the larvae from the 2013 east coast brood, pictured here, will not emerge as adults until the year 2030.

Understanding Your Subject
A tricky insect to photograph, cicadas are predominantly fossorial. The larvae of various species spend 2 to 17 years, on average, underground feeding off the sap in plant roots.

Locating Your Subject
Locating cicadas requires some basic detective skills coupled with enduring patience. To locate a calling population, start your search with your ears and become familiar with the sounds that male cicadas make while enticing females. Once an active population is audibly identified, attempt to locate a pre-molt nymph on nearby trees and shrubs. You will likely encounter the exoskeleton remains (exuvia) of nymphs that have previously molted and since flown away. Do not handle the molting nymphs as they can be easily damaged during this fragile life-stage. Locating cicadas at night is often easier, but it poses the increased challenge of nighttime photography.

Shooting Your Subject & Photographic Process
The facing-page image was shot from a tripod with the camera positioned 2.1 feet away from the subject at a slight upward angle, allowing the sky and distant horizon to serve as the image background.

Capturing multiple individuals on a single blade of grass was important to clearly elucidate the mass emergence, which characterizes the periodical cicadas. As a biologist, I was elated to document the preflight behavior of these insects—as well as to highlight their brilliant red eyes and orange venation of their forewings. This image shows how macrophotography can easily serve the dual purpose of scientific documentation and artistic expression.

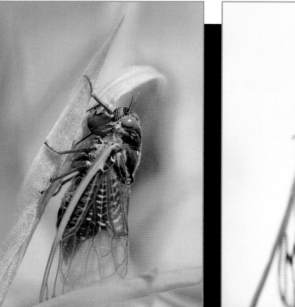

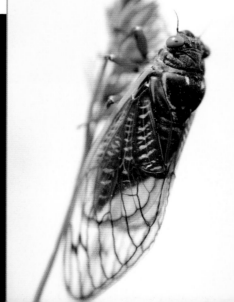

TECH SPECS ►
- Nikon D7000 body
- Nikon AF-S VR Micro-Nikkor 105mm lens
- f/9.5 at 1/45 second, ISO 400
- Natural light conditions: overcast

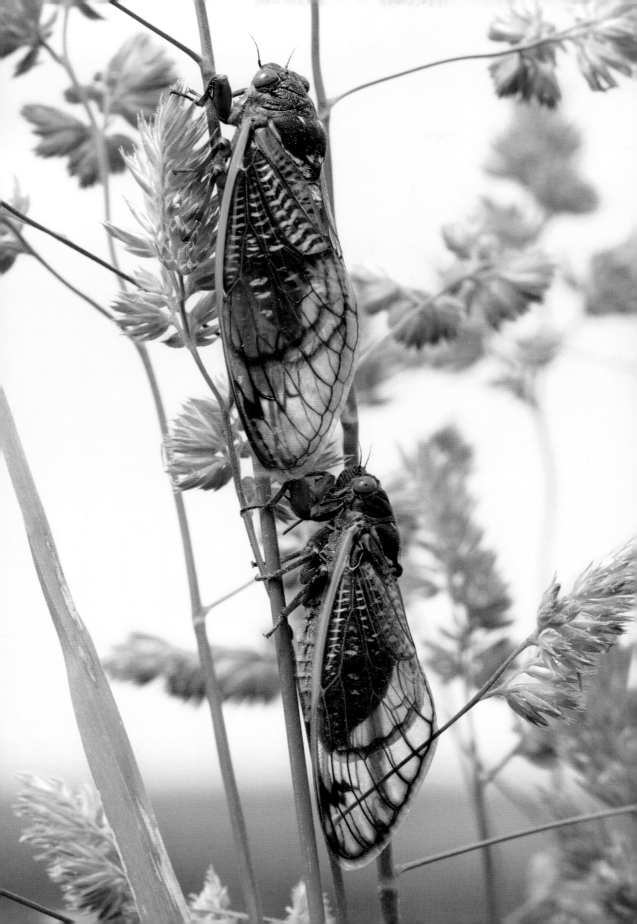

2. Connecting Subjects to the Environment

Jagged Ambush Bugs ■ *Phymata* spp.

Ambush bugs occasionally engage in a behavior known as coupling, during which they climb onto each other and work together to capture large prey.

Understanding Your Subject

Alien in appearance, ambush bugs have modified raptorial front limbs that are specially designed to capture prey of a greater size. Their tendency to lie motionless in ambush, coupled with their wide variety of colors, makes these insects the perfect group to explore with various macrophotography techniques.

Locating Your Subject

Ambush bugs inhabit open fields where they can be found on a variety of flowers during warmer months. When looking for these insects, choose plants with flower clusters (Queen Anne's Lace, Goldenrods, Joe-pye weeds etc.) and diligently search each square inch. These experts of concealment take disruptive camouflage to the extreme (as seen in the images to the left), using their colors and patterns to masterfully hide when in ambush of prey.

Shooting Your Subject & Photographic Process

The image on the facing page was shot with the camera hand-held and positioned 1.1 feet away from the subject at

TECH SPECS ▶

- Nikon D7000 body
- Nikon AF-S VR Micro-Nikkor 105mm lens
- f/9.5 at 1/60 second, ISO 400
- Natural light conditions: overcast

a downward angle of approximately 45 degrees. The subject was positioned diagonally through the center of the composition to add visual interest. When I first encountered this ambush bug, I was immediately struck by the dorsal color and pattern mimicking the pink buds of the Joe-pye weed.

Although I do not often shoot at angles superior to my subjects, this camera position was unavoidable to accurately capture the entire insect. I shot f/9.5 to capture the perfect balance, highlighting and connecting the subject to the flower buds, while achieving a soft background to prevent a muddled composition.

❝ Alien in appearance, ambush bugs have modified raptorial front limbs that are specially designed to capture prey of a greater size. ❞

Camera Position
I often shoot on a plane that is level with or slightly below my wildlife subjects. This prevents the photographer from looking superior to the subject, a common issue when taking photos from above.

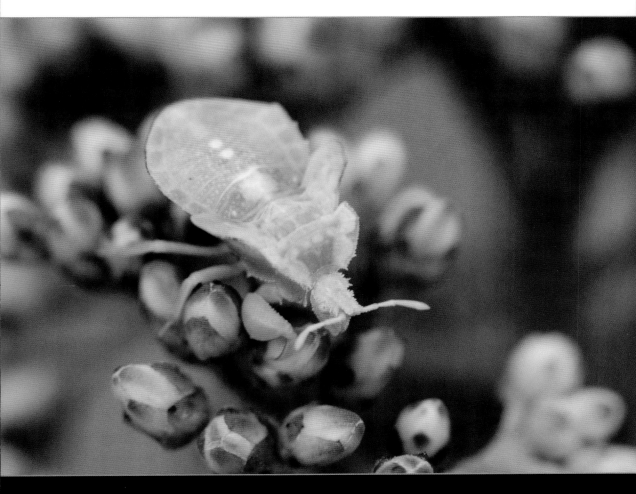

3. Following Your Subject

Banded Assassin Bug ■ *Pselliopus cinctus*

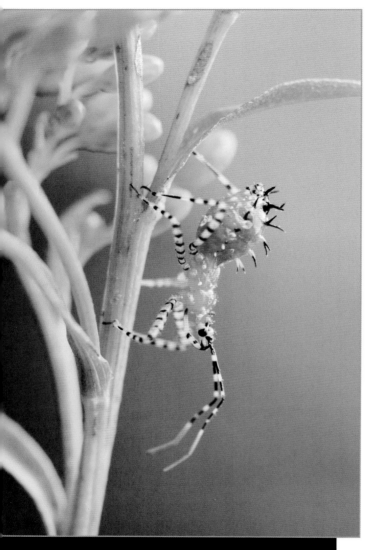

The eastern bloodsucking conenose, a parasitic individual of the assassin bug family, occasionally feeds on the blood of humans as they sleep.

Understanding Your Subject

Assassin bugs are a small group of insects with an alien appearance and varied color. As active predators, they hold down their victims with powerful front legs, injecting them with a venom that causes paralysis. Sucking the internal fluids from their bodies until they are dry, assassin bugs play an important role in maintaining the ecological balance between insects and plants.

Locating Your Subject

Assassin bugs occur in a variety of habitats, including backyards, where they are often encountered actively stalking prey on plants. Concentrate your searches in and around flowering plants where the greatest density of prey species occur. Assassin bugs are easier to photograph when they are flightless nymphs, prior to their wing development. At this stage, they typically remain on a single flower cluster.

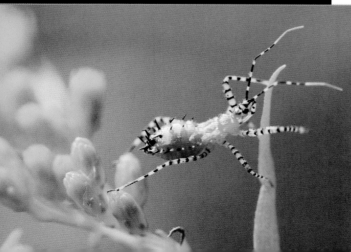

⚠ **CAUTION**

Assassin bugs are capable of delivering a painful but, in most cases, harmless bite.

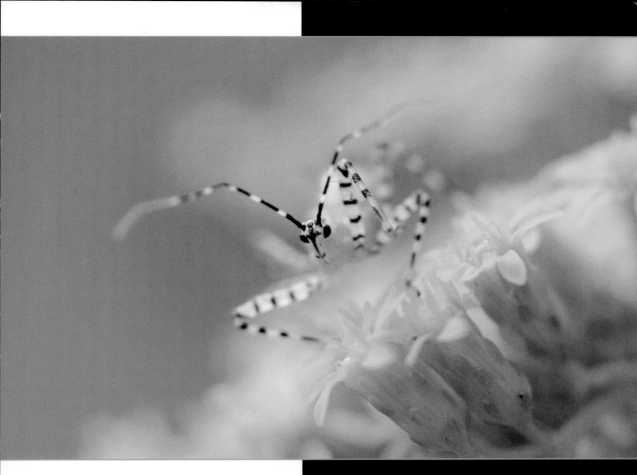

Shooting Your Subject & Photographic Process

The image above was shot hand-held with the camera positioned 1.1 feet away from the subject and on a level plane with it. Assassin bugs frequently move from plant to plant, leaving limited time to shoot. To capture your desired image, slowly follow your subject, being careful not to make any sudden movements that will likely scare them away.

In this image, I wanted to capture the subject head-on, reducing the almost distracting detail of the subject's lateral view. By using a wider aperture of f/5.6 I was able to focus the image on the extreme anterior, only faintly highlighting the black and white banding of the front limbs and antennae. Since assassin bugs are almost always moving, shooting at $1/90$ second or faster is important to eliminate motion blur.

TECH SPECS ▲
- Nikon D7000 body
- Nikon AF-S VR Micro-Nikkor 105mm lens
- f/5.6 at 1/90 second, ISO 400
- Natural light conditions: overcast

❝ Assassin bugs play an important role in maintaining the ecological balance between insects and plants. ❞

4. Understanding Animal Behavior

Oriental Beetle ■ *Exomala cf. orientalis*

Oriental beetles are native to Asia but have successfully invaded the United States, hitching rides as larvae in the soil of potted nursery stock.

Understanding Your Subject

Oriental beetles belong to a large and diverse family commonly known as scarab beetles. Adult oriental beetles are typically no more than ½ inch in length with variable colors and markings.

Locating Your Subject

Many scarab beetles are nocturnal and seen congregating around porch lights at night.

There are a few commonly recognized diurnal species. One is the Japanese Beetle *(Popillia japonica)*, which is often considered a pest because it feeds on backyard vegetation. Others, like the Rainbow Scarab *(Phanaeus vindex)*, are attracted to dung and play important roles in environmental waste cleanup.

Shooting Your Subject & Photographic Process

The image below was shot from a tripod-mounted camera positioned 1.7 feet away from the subject and at a slightly lowered angle. I was photographing a housefly when this beetle interrupted the shoot. By quickly

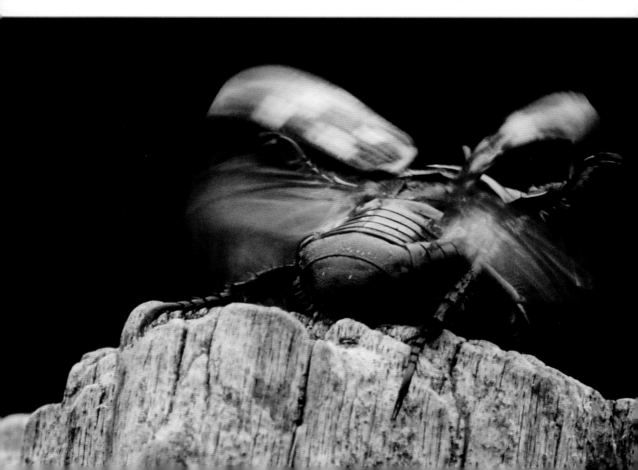

adjusting my camera settings, I was able to capture the top-right image, highlighting the purple and green iridescence of the pronotum as the beetle explored the wooden post.

Instead of repositioning the camera, I experimented with an uncommon posterior view of the subject. By shooting at $\frac{1}{90}$ second, a relatively slow shutter speed for quick motions, I was able to freeze the body of the subject, while still capturing the motion of the elytra and hind wings (bottom left). To capture flight consistently, a basic understanding of animal behavior is

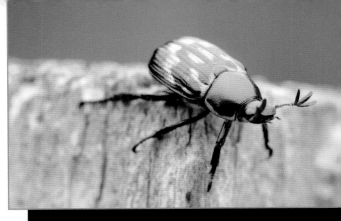

❝ I was photographing a housefly when this beetle interrupted the shoot. ❞

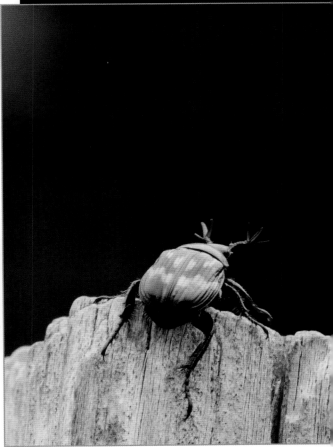

◀ **TECH SPECS**

- Nikon D7000 body
- Nikon AF-S VR Micro-Nikkor 105mm lens
- f/16 at 1/90 second, ISO 560
- Natural light conditions: overcast

more important than expert knowledge of photographic technique. Knowing that most beetles tend to take flight from the highest point in their environment, I was able to direct my camera lens toward the top of the post and have plenty of time to achieve my focus prior to takeoff.

5. Creating Action Shots
Carpenter Ant ■ *Camponotus* sp.

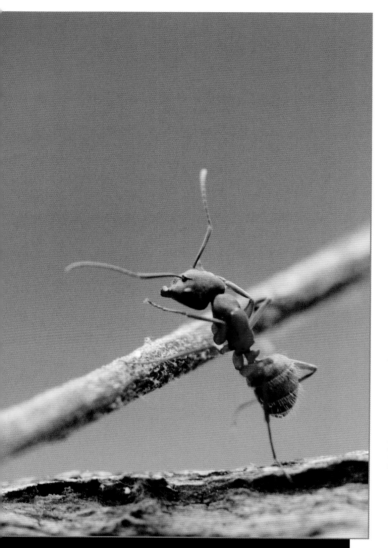

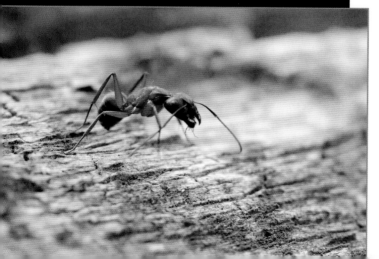

Carpenter ants feed on dead insects, not on the wood from the trees that they carve out while making their homes.

Understanding Your Subject

Carpenter ants are named for their ability to construct complex, hollowed-out galleries in dead wood. These serve as a home for the colony. Carpenter ants are common throughout the world and range from solid red, to black, or variable combinations thereof. They are responsible for vast property damage as a result of their nest-building behaviors.

Locating Your Subject

When not found in or around your home, carpenter ants are easily encountered in forested habitats. You'll find them walking on (or within close proximity to) moist, dead, rotting logs.

Respect the Subject

When staging action images, never force your subjects to act in a way that could potentially stress or harm them. Always allow animals to overcome obstacles on their own.

Shooting Your Subject & Photographic Process

The image below was shot hand-held with the camera positioned on a level plane with the subject and at a distance of 1.3 feet. To enhance the action of this image, I staged a small obstacle for my subject to overcome. To highlight the ant's climbing motion, I created a small focal area by shooting at f/5.6 and placed a stick diagonally through the image and at a slight angle away from the camera. The shallow depth of field adds a softness and lessens the distraction of the image being chopped in half by the stick. Although working within a shallow depth of field can be challenging, if you take great patience with your subject the end result will be well worth the additional time.

66 Carpenter ants are named for their ability to construct complex, hollowed-out galleries in dead wood. These serve as a home for the colony. 99

TECH SPECS ▼

- Nikon D7000 body
- Nikon AF-S VR Micro-Nikkor 105mm lens
- f/5.6 at 1/90 second, ISO 800
- Natural light conditions: sunny, shot in shade

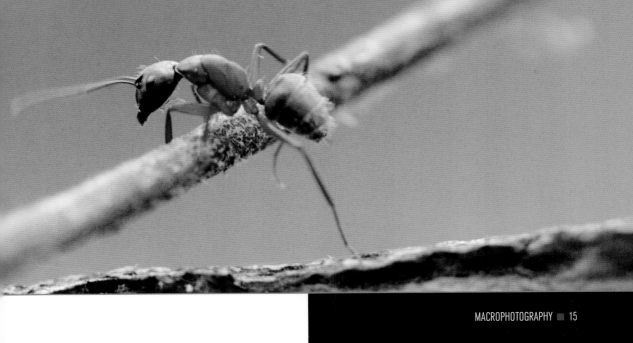

6. The Impact of Backgrounds

Bluet Damselfly ■ *Enallagma* sp.

Juvenile (or naiad) damselflies are fully aquatic and can be used as an indicator of water-quality based on their species diversity and abundance within a stream.

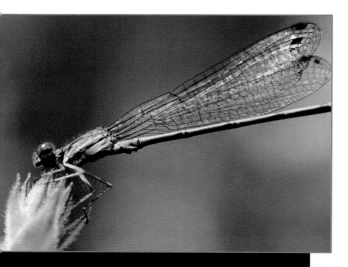

Understanding Your Subject

Damselflies are a diverse group of predatory aerial insects that are closely related to the dragonflies. They are characterized by having slender bodies and membranous wings, which they often fold behind their backs when at rest.

Locating Your Subject

Found on every continent except Antarctica, damselflies are commonly encountered in emergent wetland vegetation alongside streams, rivers, ponds, and lakes. They can also be encountered in the surrounding upland habitats, especially in fields and meadows.

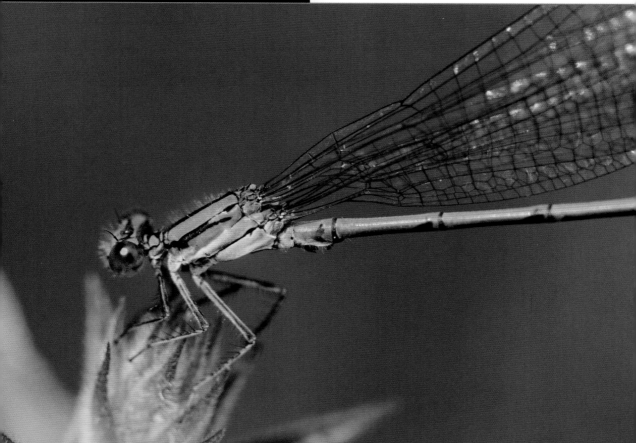

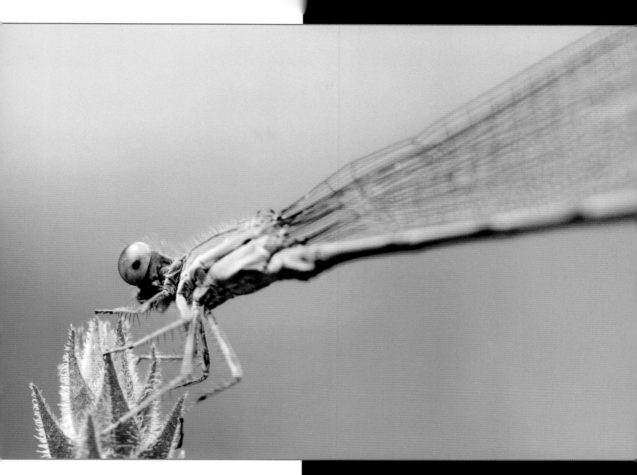

Shooting Your Subject & Photographic Process

These images were shot from a tripod with the camera positioned 1.1 feet away from the subject and directed at an upward angle from slightly behind the damselfly.

The impact that backgrounds can have on the same subject is evident in this series. In the first image (facing page, top), the multiple background colors compete with the subject and detract from the overall shot. In

TECH SPECS ▲

- Nikon D7000 body
- Nikon AF-S VR Micro-Nikkor 105mm lens
- f/9.5 at 1/60 second, ISO 400
- Natural light conditions: sunny

the second image (facing page, bottom), the background is monochromatic and contrasts with the subject. In the final shot (above), the soft background of the blue sky complements the damselfly and provides the most visually pleasing backdrop.

You may also notice the effect that the backgrounds have on the subject's overall coloration, with the image above being the most true to the actual color of the damselfly.

Behavioral Patterns

Often damselflies and dragonflies land on a select few plants while breaking from their aerial hunts. Observe the behavioral patterns of the individual and then set up your camera at one of their resting areas.

7. Connecting With Your Subject

Dogbane Leaf Beetle ■ *Chrysochus auratus*

The beautiful iridescent colors seen on beetles result from light reflecting off tiny angled plates covering the pigmented layer of the elytra (hardened forewing).

Understanding Your Subject

Beetles comprise the largest order of animals worldwide, with some 350,000 species described. Occurring in a variety of colors, shapes, and sizes, beetles inhabit most all terrestrial and freshwater environments. This makes them excellent and obtainable macrophotography subjects.

Locating Your Subject

Dogbane leaf beetles are readily encountered on both dogbane and milkweed plants, where they feed on the toxic, milky sap.

Shooting Your Subject & Photographic Process

The facing-page image was shot from a tripod with the camera at a distance of 1.1 feet and on a level plane with the subject. Capturing the iridescent color with an emotional connection took persistence, patience, and multiple subjects.

Although the images to the left capture the beauty of the dorsal and ventral surfaces of the dogbane leaf beetle, both lack emotion. It was not until I located the active subject in the facing-page image that I satisfactorily captured the overall brilliance of this species. By positioning the camera in the path of the moving subject I was able to capture a quick glance from this individual, emotionally connecting the camera with the subject as it paused along the leaf periphery.

Macrophotography often requires persistence and patience. This image documents just $\frac{1}{45}$ second in time, but it required the better part of an hour to capture.

⚠ **CAUTION**

Although harmless, dogbane beetles are toxic and capable of delivering a noxious spray if physically disturbed.

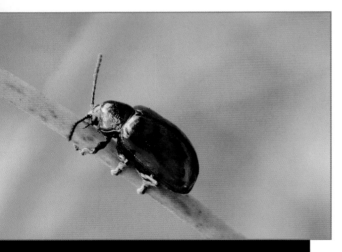

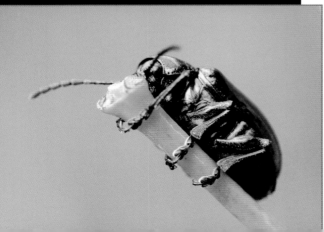

TECH SPECS ▶

- Nikon D7000 body
- Nikon AF-S VR Micro-Nikkor 105mm lens
- f/9.5 at 1/45 second, ISO 400
- Natural light conditions: overcast

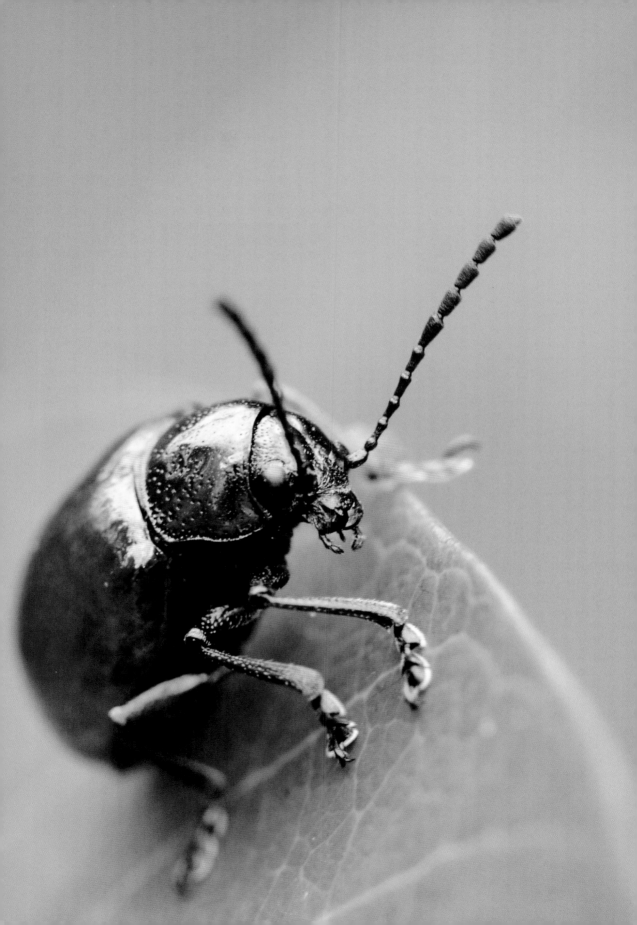

8. Don't Be the Predator

Eastern Tailed-Blue Butterfly ■ *Cupido comyntas*

The larvae of many blue butterfly species are dependent on ants for protection. In turn, they occasionally furnish the ants with a sweet sugary treat.

Understanding Your Subject

Eastern tailed-blue butterflies are a small, common, and easily startled species. The dorsal surface of the wings are blue in males and brown in females, with beautifully patterned dorsal and ventral surfaces adorned in orange spots.

Locating Your Subject

Eastern tailed-blue butterflies spend much of their adult life feeding in open habitats on low-growing flower species of the legume and pea families. When locating this species, look for the blue or brown wings during flight, carefully observing where they land.

Shooting Your Subject & Photographic Process

The final image (facing page, top) was shot from a tripod with the camera positioned 1.3 feet away from the

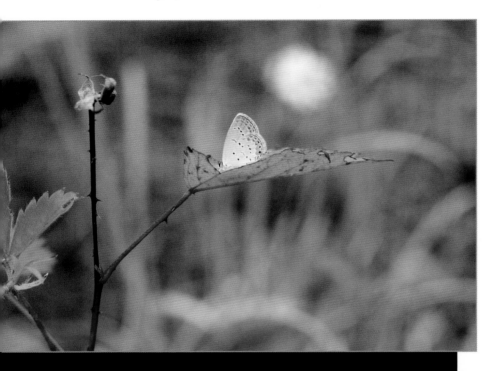

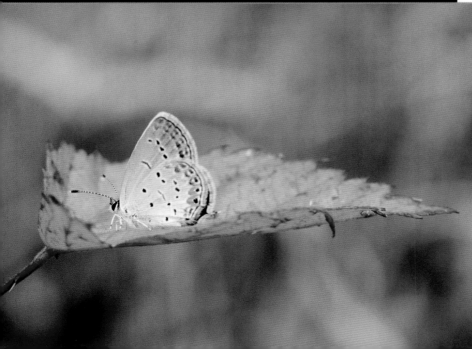

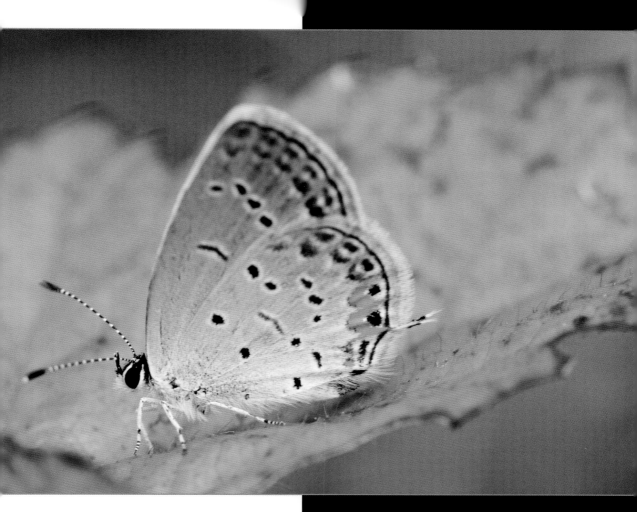

subject. To obtain an unobstructed view, the camera was positioned above the subject at a slight downward angle, effectively shooting over the upturned margin of the leaf.

I wanted to visibly document four key elements: the banded black & white antennae, the point of attachment to the leaf, the ventral orange spots, and the intact tails of this individual. To accomplish this, it was critical to approach this species slowly starting at 2.5 feet (facing page, top), then 1.6 feet (facing page, bottom), then to the final distance and camera position at 1.3 feet (as seen in the image above).

Approaching your subjects very slowly helps ensure you will not appear as a potential threat, and you will likely be rewarded with stunning close-up captures. This individual chose to alight on a Rubus species in its brilliant senescence—as if she knew this leaf was the perfect complement to her orange spots.

TECH SPECS ▲

- Nikon D7000 body
- Nikon AF-S VR Micro-Nikkor 105mm lens
- f/8 at 1/180 second, ISO 800
- Natural light conditions: overcast

9. Capturing Flight Sequences

Goldenrod Soldier Beetle ■ *Chauliognathus pensylvanicus*

Soldier beetles are also referred to as leatherwings because of their soft, leather-like elytra that is almost always hard in other beetle species.

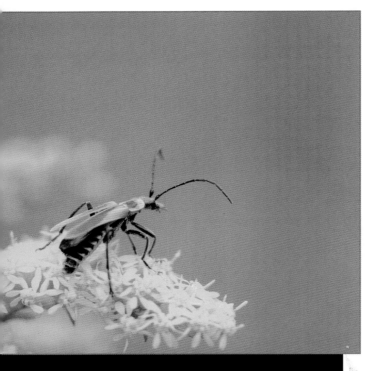

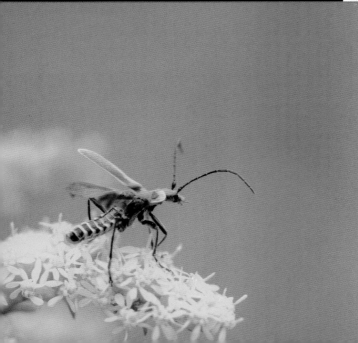

Understanding Your Subject

Capturing flight can be difficult with insects. However, soldier beetles are relatively slow and often fly from flower to flower. These two behaviors make them the ideal subjects to photograph in flight.

Locating Your Subject

Soldier beetles are commonly active during the summer and fall months. They are readily encountered in fields full of wildflowers—especially on goldenrods, where they spend their time feeding on other insects, nectar, and pollen.

Shooting Your Subject & Photographic Process

This image sequence was shot from a tripod with the camera at a distance of 1.7 feet and on a level plane with the subject. The subject was initially positioned in the bottom left corner of the frame to allow ample space to capture the flight sequence.

Setting up on the terminal cluster is important because beetles often take off from the highest position in their environment. As the beetle approached

Shutter Speed

The shutter speed plays a critical role when photographing movement. It can be effectively used in varying degrees to freeze or blur the action of your subject.

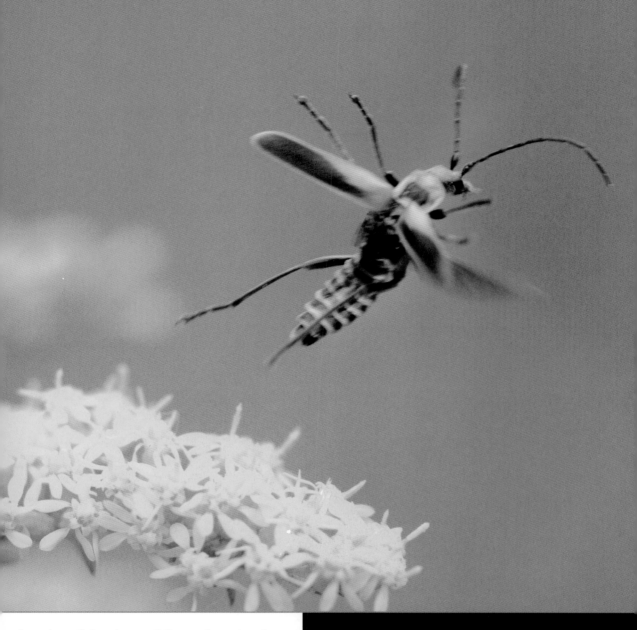

the edge of the cluster, I focused on the elytra; as soon as the elytra began to lift (facing page, bottom), I shot 10 frames in rapid succession to document the entire takeoff sequence. It is very important to watch for movement in the elytra; it's the indication a beetle is preparing for flight. Once the elytra begin to stir, you will only have a fraction of a second to react.

TECH SPECS ▲

- Nikon D7000 body
- Nikon AF-S VR Micro-Nikkor 105mm lens
- f/4.8 at 1/1000 second, ISO 800
- Natural light conditions: overcast

10. Spiders in Webs

Order *Araneae*

Spiders use silk for more than just spinning webs. Other uses include courtship, producing egg sacs, and dispersal by kiting through the wind.

> 66 With the spider illuminated in a small patch of sun, I was able highlight the incredible color and pattern details. 99

Understanding Your Subject

Spiders occur in a variety of shapes and colors and have eight legs attached to the cephalothorax (fused head and thorax). The abdomen contains the glands and spinnerets responsible for producing and laying down spider silk.

Locating Your Subject

Spiders can be located in most all habitats, including terrestrial and freshwater aquatic ecosystems. When searching for spiders in webs, focus your efforts in areas where insects are plentiful. Often, webs can be

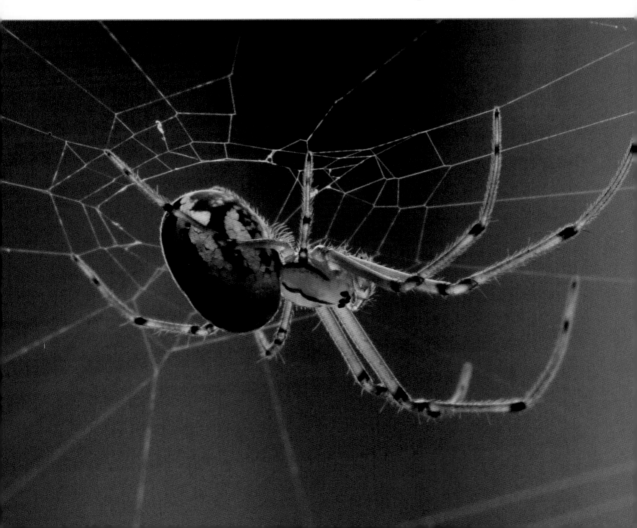

⚠ CAUTION

All spiders are venomous and are capable of injecting venom through fangs located at the end of their chelicerae. The severity of bites varies greatly with the species, ranging from harmless to deadly.

observed amongst the vegetation in fields and woodlands.

Shooting Your Subject & Photographic Process

The image below was shot from a tripod with the camera positioned 1.1 feet away from the subject and on a slight upward angle. I wanted to capture the details of both the web and spider in my composition. With the spider illuminated in a small patch of sun, I was able

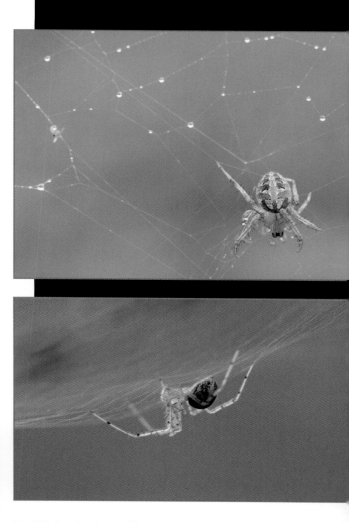

◄ TECH SPECS

- Nikon D7000 body
- Nikon AF-S VR Micro-Nikkor 105mm lens
- f/19 at 1/180 second, ISO 400
- Natural light conditions: sunny

highlight the incredible color and pattern details and make it appear as if they were stained glass. I played with various camera angles, finding my position just below the subject to be the best to capture the illuminating sunlight.

Because spider webs often move with the wind, it is best to shoot during calm conditions with lighting levels that accommodate high shutter speeds. Be aware that higher f-stops are required to capture all of the intricate details within a spider's web.

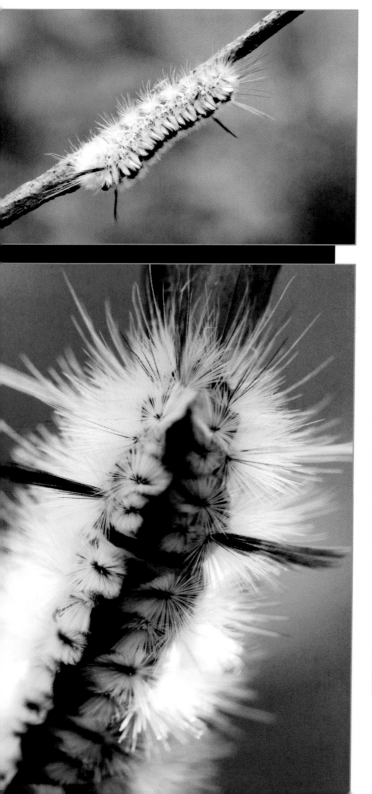

Tussocks caterpillars are known as skeletonizing feeders because they eat only the green, fleshy material of leaves and leave behind the veins or "skeleton."

Understanding Your Subject
Hickory tussocks caterpillars are covered with hair-like bristles called setae. Predominantly white, they have black tufts running along the dorsal mid-line with two longer tufts at both their anterior and posterior end.

Locating Your Subject
They are often encountered in mature woodlands where they feed on a variety of trees including the preferred hickory (*Carya* spp.) and walnut (*Juglans* spp.) species. Younger larvae feed in groups; later in development, tussocks caterpillars live a solitary existence.

Shooting Your Subject & Photographic Process
The facing-page image was shot hand-held with the camera positioned 1.3 feet away from the subject and on a level

⚠ CAUTION
The long black hairs of this caterpillar are connected to venom glands and if touched will deliver a sting. Although harmless, this sting is painful and in extreme cases may cause nausea.

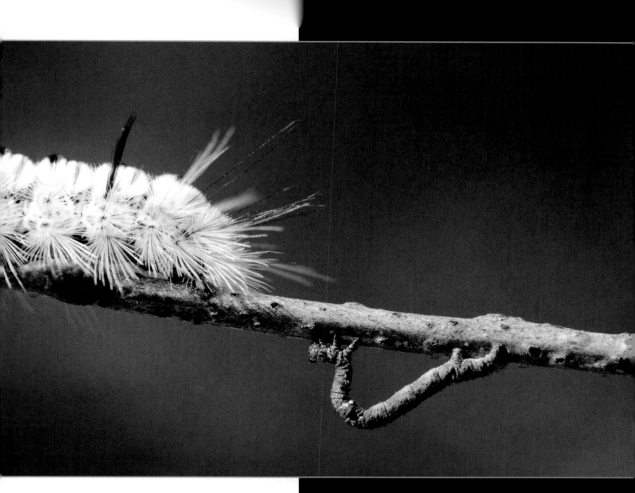

plane. This caterpillar was found on the forest floor, crawling along the pictured stick. I was very fortunate to notice a looper caterpillar, who just happened to be sharing the same downed branch as the hickory tussocks caterpillar (this was a first for me).

Although I prefer to photograph in overcast or lightly shaded conditions, positioning the stick in a sunny spot was critical to achieving the light required to fully present these caterpillars.

Because the image composition was naturally dynamic, as both caterpillars were facing each other on opposite sides of the branch, I only slightly angled the stick to highlight the subtle differences in the background color for each subject.

TECH SPECS ▲

- Nikon D7000 body
- Nikon AF-S VR Micro-Nikkor 105mm lens
- f/8 at 1/90 second, ISO 800
- Natural light conditions: sunny, shot in dappled sun

66 Positioning the stick in a sunny spot was critical to achieving the light required to fully present these caterpillars. 99

12. Shutter Release Timing
Jumping Spiders ■ Family *Salticidae*

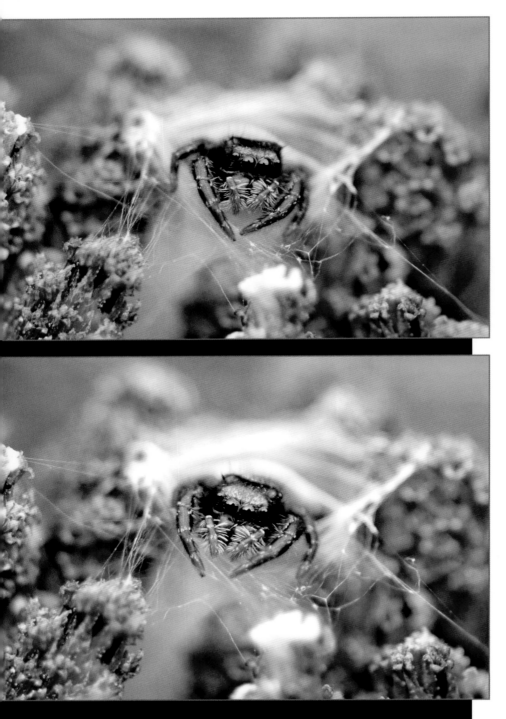

A ll spiders are venomous, and jumping spiders are no exception. They are capable of delivering a painful bite if provoked—so be sure never to corner or touch your subject.

Understanding Your Subject

Jumping spiders belong to a large, often colorful, and arguably adorable family of spiders. Lending to their name, they actively subdue their prey by jumping on them in ambush instead of spinning webs.

Locating Your Subject

Jumping spiders can be found in most habitats, from forests and fields to urban and suburban backyard gardens. During

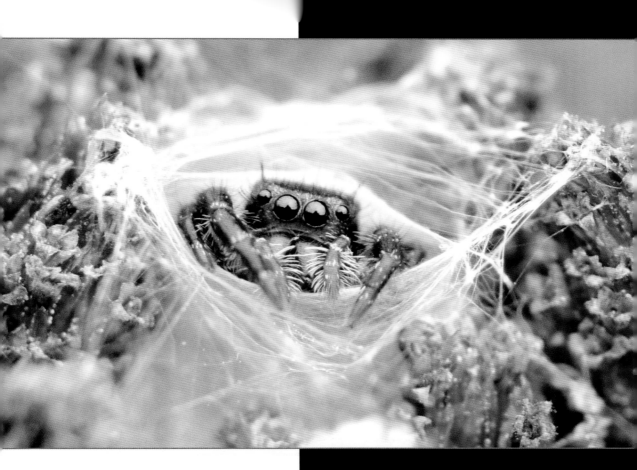

the day, they are easily encountered in and around plants, a favored haunt to capture their prey.

Shooting Your Subject & Photographic Process

These images were shot from a tripod with the camera positioned at a distance of 1.2 feet and on a level plane with the subject.

The jumping spider was darting in and out of the web. This functioned like a trap door, opening for ambush and securely closing after retreat. Although extremely amusing to observe, this behavior made it a difficult subject to capture.

It was not until the spider paused in curiosity, making eye contact with the camera (above), that I satisfactorily made a connection with this subject. In anticipation of the

TECH SPECS ▲

- Nikon D7000 body
- Nikon AF-S VR Micro-Nikkor 105mm lens
- f/5.6 at 1/250 second, ISO 800
- Natural light conditions: overcast

spider's emergence from the web, I depressed the shutter halfway down to lock the focus, releasing the button the moment we made eye contact.

> ❝ They actively subdue their prey by jumping on them in ambush instead of spinning webs. ❞

13. When Opportunity Knocks

Mayfly ■ *Callibaetis ferrugineus*

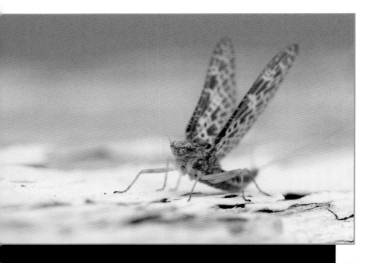

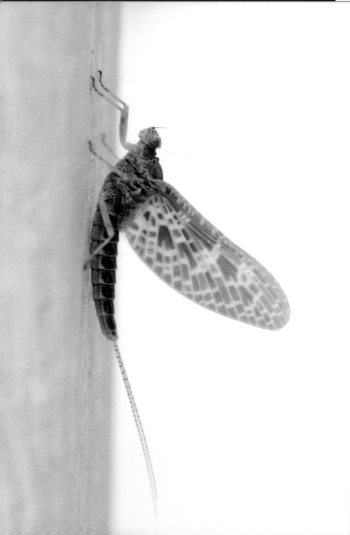

Mayflies are an important food source for many fish species and are often tracked and mimicked by fly fishermen to increase their likelihood of catching trout.

Understanding Your Subject

Mayflies have a complex life cycle beginning in freshwater aquatic habitats where the juveniles (naiads) feed primarily on algae and detritus. Adult mayflies are aerial and often survive for only a day or two, allowing themselves just enough time to reproduce.

Locating Your Subject

Mayflies are easily encountered by freshwater aquatic habitats including rivers, streams, lakes, and ponds. They are often seen resting on emergent vegetation along the periphery of freshwater habitats.

66 Whether working in the field as a biologist or strolling through my backyard, I always have my camera fully charged and ready to shoot. 99

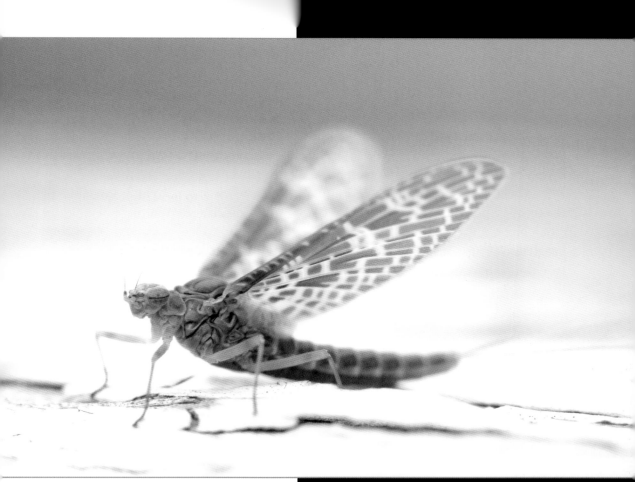

Shooting Your Subject & Photographic Process

The image above was shot from a tripod with the camera positioned at a distance of 1.1 feet and on a level plane with the subject.

Whether working in the field as a biologist or strolling through my backyard, I always have my camera fully charged and ready to shoot. This mayfly was observed resting on the railing of my backyard deck—a great example of how readiness allows one to take full advantage of the rich diversity surrounding everyday life.

Slowly getting into position, so as not to scare off my visitor, I set up the tripod and camera and began shooting. I captured my

TECH SPECS ▲

- Nikon D7000 body
- Nikon AF-S VR Micro-Nikkor 105mm lens
- f/11 at 1/60 second, ISO 400
- Natural light conditions: overcast

subject in various angles and poses. Due to the low light I was forced to shoot at f/11 to capture the intricate details of this subject's head, thorax, and wings.

The background is the peeling paint of the deck railing. This created beautiful lines throughout the composition.

14. Visually Pleasing Poses
Pandorus Sphinx Moth Caterpillar ■ *Eumorpha pandorus*

Pandorus sphinx caterpillars are thought to be named for the "sphinx-like" appearance that results from their tendency to tuck their first two body segments into the third.

Understanding Your Subject
Pandorus sphinx moth caterpillars are robust, 3.5-inch caterpillars that occur in a variety of colors, including green, pink, orange, cinnamon, brown, and black. During the first half of their infancy, individuals have a posterior "horn." This is lost and replaced by a lenticular button that resembles an eye.

Locating Your Subject
Pandorus sphinx caterpillars are often found feeding on grapevines and Virginia creeper

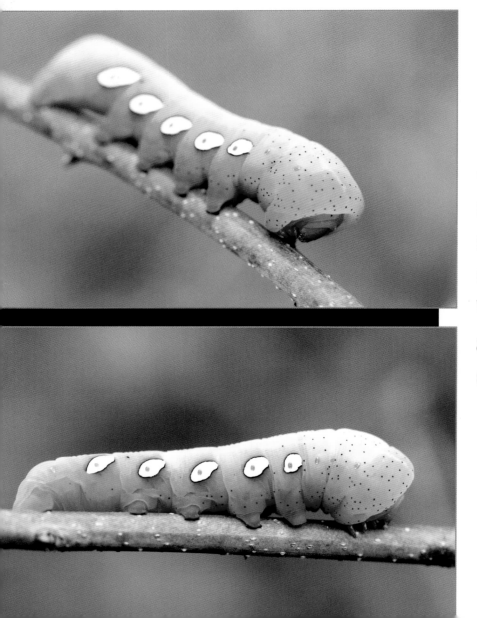

❝ Pandorus sphinx caterpillars are often found feeding on grapevines and Virginia creeper at field/forest edges. ❞

at field/forest edges. The pictured individual was encountered on a power line right-of-way.

Shooting Your Subject & Photographic Process

The image below was shot while I was lying on the ground with the camera hand-held. I had it positioned 1.6 feet away from the subject and tilted on a slight upward angle. The vine was angled through the frame to relax the overall image composition.

This brilliantly colored individual truly speaks for itself. Capturing this image did not require a large amount of photographic creativity—but, instead, a basic understanding of caterpillar behavior. Although the first two images (facing page) capture the beauty of this subject's color and lateral eye markings, an overall natural posture is absent. This causes the subject to appear uncomfortable.

Then, I allowed the caterpillar to hang naturally, using the small hooks on its prolegs (called crochets). This relaxed its pose and allowed for a slightly arched back, lending to the overall pleasing aesthetic of the final image (below).

TECH SPECS ▼

- Nikon D7000 body
- Nikon AF-S VR Micro-Nikkor 105mm lens
- f/4 at 1/90 second, ISO 400
- Natural light conditions: overcast

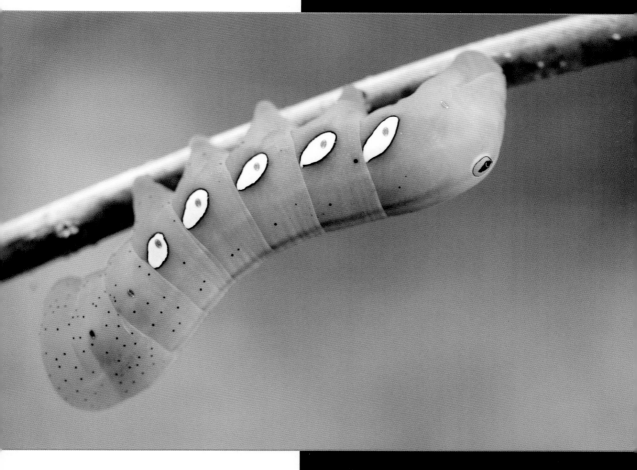

15. Capturing the Struggle for Life

Chinese Praying Mantis ■ *Tenodera sinensis*

Female praying mantises are often accused of eating their mates. However, this behavior is rarely observed outside of the confined laboratory conditions from which the myth arose.

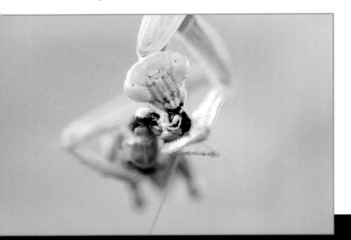

Understanding Your Subject

The Chinese mantis is slender, ranging from brown to green in color, with a green lateral stripe bordering the side of each front wing. Reaching lengths in excess of 4 inches, they are one of the largest mantis species.

Locating Your Subject

Masters of camouflage, mantises are often encountered on flowering plants in open-canopy habitats, such as fields and meadows. As the summer progresses, juvenile mantises increase in size as they reach adulthood. This makes them easier to encounter during the later summer months.

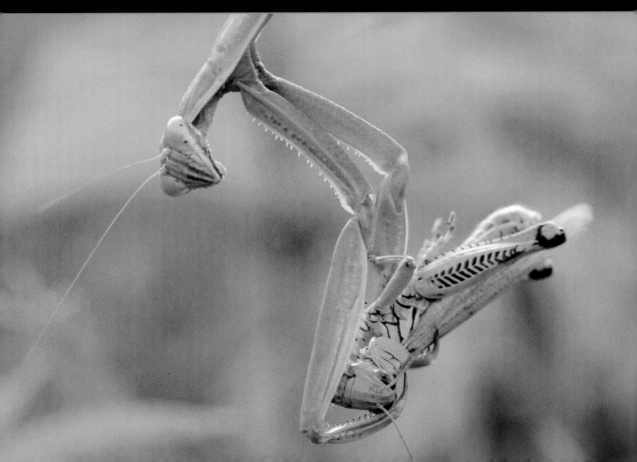

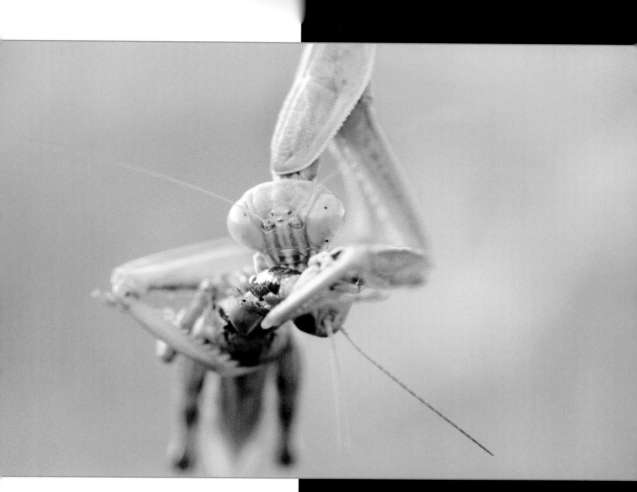

Shooting Your Subject & Photographic Process

The image above was shot with the camera hand-held and positioned at a distance of 1.4 feet and on a level plane with the subject.

For some, the subject matter may appear disturbing and gruesome. To me, it eloquently captures the everyday struggle for survival in the natural world. Keeping the focal point on the action of feeding was the most important image component to me. Selecting an aperture of f/5.6 kept the overall shape, form, and identity of the prey subject clear, while still driving the viewer's eye to the central focal point of the image.

Adding to the allure of this composition is the piercing stare of the mantis as it devours the grasshopper.

TECH SPECS ▲

- Nikon D7000 body
- Nikon AF-S VR Micro-Nikkor 105mm lens
- f/5.6 at 1/90 second, ISO 800
- Natural light conditions: sunny

❝ Keeping the focal point on the action of feeding was the most important image component to me. ❞

16. Choosing Focal Points on Subjects

Saddleback Caterpillar ■ *Acharia stimulea*

Although beautiful, Saddleback caterpillars are capable of delivering one of North America's most toxic and painful caterpillar stings.

Understanding Your Subject

Saddlebacks belong to the slug caterpillar family, which is known for the often striking appearances of its members. Saddlebacks feed in groups during their early larval development, then singly during later stages. As with many caterpillars, the beauty of the larval stage far exceeds the drab coloration of the adult moth.

Locating Your Subject

Saddleback caterpillars can be found in a variety of habitats, ranging from forests to

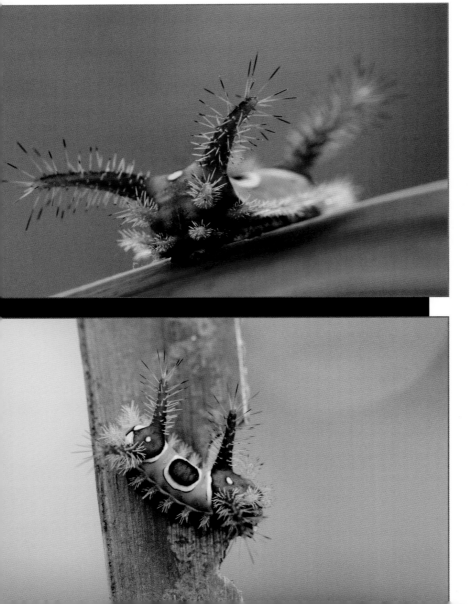

❝ As with many caterpillars, the beauty of the larval stage far exceeds the drab coloration of the adult moth. ❞

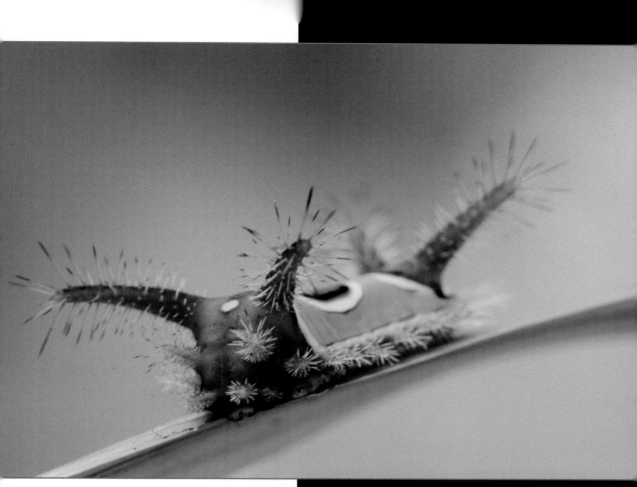

backyards, where they commonly feed on a variety of plants, including deciduous trees, grasses, and ornamental species. I often encounter this species at wetland edges on wide-blade species such as cattails and irises.

TECH SPECS ▲

- Nikon D7000 body
- Nikon AF-S VR Micro-Nikkor 105mm lens
- f/19 at 1/15 second, ISO 560
- Natural light conditions: sunny

Shooting Your Subject & Photographic Process

The above image was shot from a tripod with the camera positioned 1.1 feet away from the subject. Shooting at a slight upward angle allowed the sky to serve as the image background. The caterpillar fades into the background at a 45 degree angle, creating a dynamic composition. The intimidating black-tipped spines covering the fleshy anterior and posterior tubercles accurately capture the striking, yet threatening, beauty of this species. It was important not to allow myself to be distracted by the brilliant greens of this subject, instead focusing on the anterior spines to highlight one of North America's greatest caterpillar defenses.

> ⚠ **CAUTION**
> Hairy and spiny caterpillars are often toxic, causing irritation if rubbed against or handled.

17. Sun Glare Reduction

Spotted Cucumber Beetle ■ *Diabrotica undecimpunctata howardi*

Spotted cucumber beetles carry a bacterial disease that they spread to cucumber crops, causing significant crop damage and agricultural loss each year.

Understanding Your Subject
Spotted cucumber beetles occur across North America and are most noted for their impact on agriculture. Every year, they cause major crop damage, especially to corn, muskmelon, and (as the name implies) cucumbers. Adults feed off the leaves and stems of the crop plant while the larvae burrow into the stems and roots.

Locating Your Subject
Spotted cucumber beetles are readily encountered in open fields and meadows, especially those in close proximity to agricultural lands. They can also be encountered in backyard gardens.

Shooting Your Subject & Photographic Process
These images were shot hand-held with the camera positioned at a distance of 1.5 feet and on a slight angle above the subject. In the first image (below), simplicity was

TECH SPECS ▼
- Nikon D7000 body
- Nikon AF-S VR Micro-Nikkor 105mm lens
- f/6.7 at 1/1500 second, ISO 800
- Natural light conditions: sunny

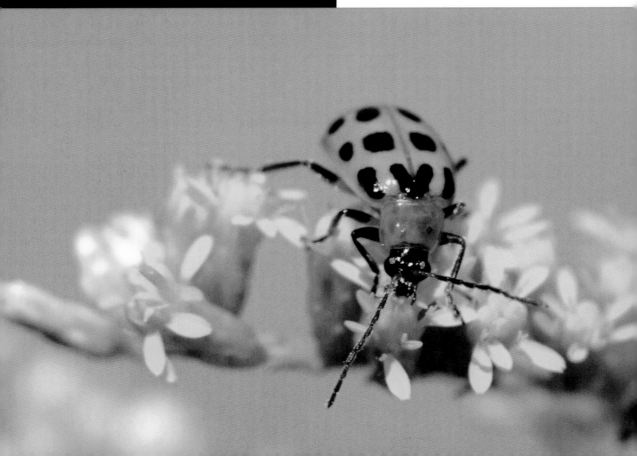

achieved by blending the various shades of yellow in the foreground and background to create a monochromatic wash that is visually pleasing.

The blue sky above the horizon in the second image (below) sets a completely different mood, making the subject and goldenrod flowers pop out of the composition.

This subject was challenging to capture for two reasons. First, it was positioned in the bright midday sun. Second, it was making quick movements from plant to plant.

When shooting in sunny conditions you must make sure, as much as possible, to

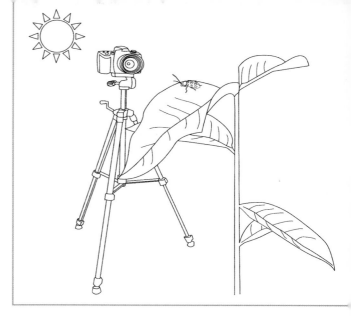

66 Adults feed off the leaves and stems of the crop plant, while the larvae burrow into the stems and roots. 99

reduce the reflective glare on your subject. To eliminate glare, it is helpful to experiment with various camera angles and positioning. If you are still unable to remove this distraction from the image, try using your body to cast an artificial shadow over your subject (see diagram above).

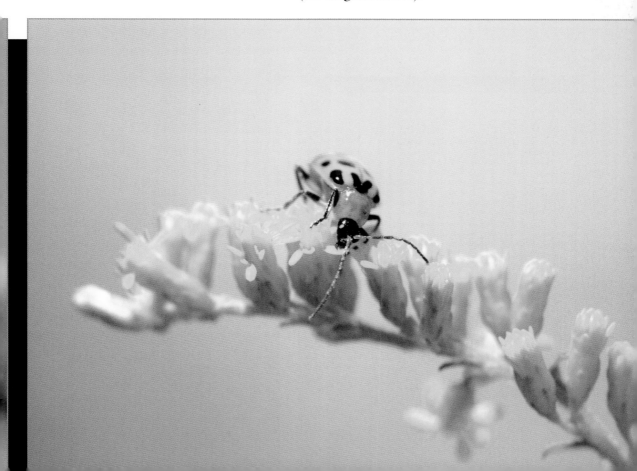

18. Subjects Position Themselves

Fly ■ Order *Diptera*

The mouthparts of flies are highly adapted based on feeding preference. For example, houseflies have structures for sponging food in liquid form, while mosquitoes have piercing parts to acquire blood meals.

Understanding Your Subject

The order *Diptera* includes all true flies, distinguished by their single pair of membranous forewings and reduced, club-shaped hind wings called halteres, which function to maintain balance in flight. They occur in a variety of shapes, sizes, and colors, displaying exquisite anatomical details. This makes them excellent macrophotography subjects.

Locating Your Subject

Flies are widespread, occurring in most habitats from urban metropolitan areas to wilderness areas alike.

Shooting Your Subject & Photographic Process

The image on the facing page was shot from a tripod with the camera at a distance of 1.1 feet and on a level plane with the subject.

In my attempts to shoot this fly head-on, I learned a valuable lesson in photography, which is to let your subjects position themselves. I first took the approach of moving myself around the subject, which to my frustration led the fly to reposition itself perpendicular to the camera with every rotation I made (top left).

Quickly realizing my chase was futile, I pulled out my tripod and set the camera up to frame the dead flower head. After only a few minutes of motionless waiting, the fly relaxed and repositioned itself facing the camera head-on in my intended pose. Snapping a few quick shots I was able to capture the bottom-left photo. Cropping that image in post-production yielded the final image on the facing page.

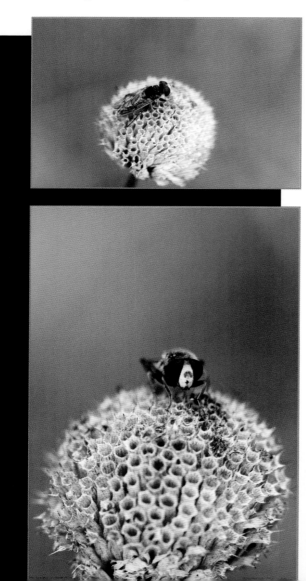

TECH SPECS ▶

- Nikon D7000 body
- Nikon AF-S VR Micro-Nikkor 105mm lens
- f/8 at 1/180 second, ISO 560
- Natural light conditions: overcast

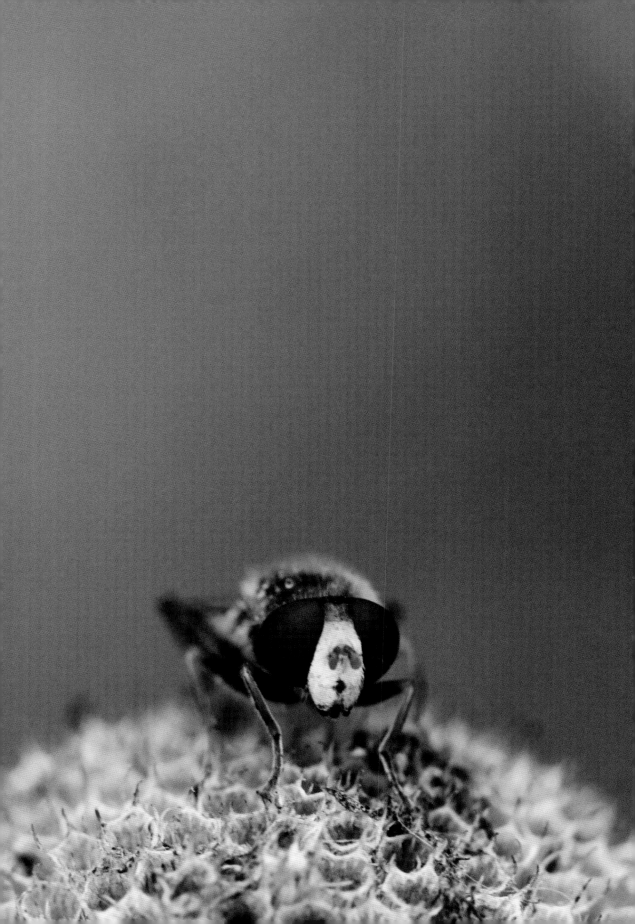

19. The Assassins

Robber Fly ■ Family *Asilidae*

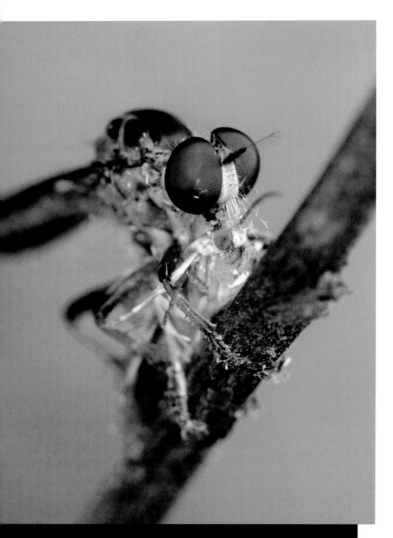

Robber flies inject their prey with saliva containing neurotoxic and proteolytic enzymes, quickly immobilizing and liquefying their prey.

Understanding Your Subject

Robber flies are notoriously aggressive predators, seeking out their prey in mid-flight. They have a specialized proboscis that conceals a sharp, sucking hypo-pharynx used to drink the liquefied remains of their prey. They play an important role in keeping insect populations in balance.

Locating Your Subject

Robber flies prefer open and dry conditions, but can be found in a wide variety of habitats, including meadows, forests, and backyards. Look for robber flies perched, resting, or feeding on vegetation. I typically encounter them on tall, dead, herbaceous plant stems.

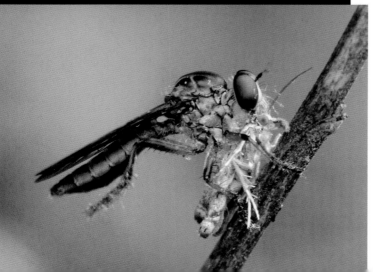

❝ They have a specialized proboscis that conceals a sharp, sucking hypo-pharynx used to drink the liquefied remains of their prey. ❞

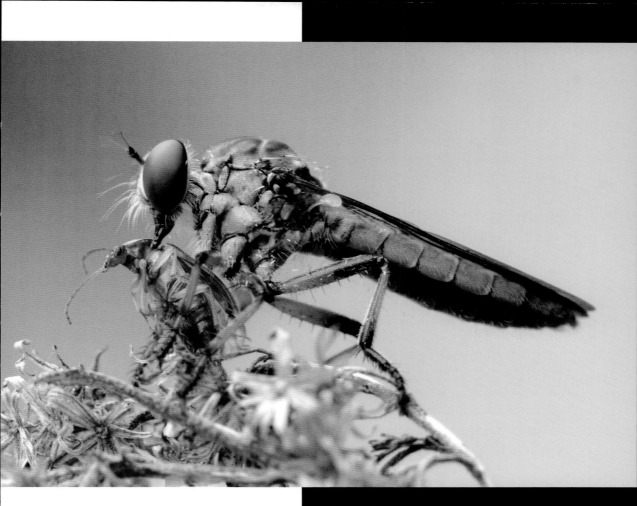

Shooting Your Subject & Photographic Process

The image above was shot from a tripod with the camera at a distance of 1.3 feet and on a level plane with the subject.

If you're interested in targeting predatory insects feeding, the robber fly is a great choice. During the course of the shoot, this fly captured and ate two different species. My goal was to capture the specialized proboscis sticking into the subject as this fly fed.

Due to the fly's large size, I shot at f/11 and $\frac{1}{90}$ second to allow for enough depth of field in the image. The sun illuminated the background vegetation and added a nice splash of color to this image, complementing the subject's green eyes.

TECH SPECS ▲
- Nikon D7000 body
- Nikon AF-S VR Micro-Nikkor 105mm lens
- f/11 at 1/90 second, ISO 800
- Natural light conditions: sunny

20. Documenting Behaviors

Sweat Bee ■ *Agapostemon* sp.

Sweat bees acquired their common name due to their attraction to the salt in human perspiration.

Understanding Your Subject
Sweat bees belong to a family of bees that are often metallic. They forage on nectar and pollen, which they mass-provision to feed their offspring in underground dwellings.

Locating Your Subject
Sweat bees are commonly encountered in open fields and meadows where they actively forage. Anecdotally, they seem to have a preference for purple flowers. Active ground hives are often located within close proximity to foraging areas.

Shooting Your Subject & Photographic Process
I shot this image while lying on the ground with the camera resting on a t-shirt. It was

> **⚠ CAUTION**
> Female sweat bees are capable of delivering a sting, but it is far less painful than that of their cousin, the honey bee.

positioned 1.5 feet away from the subject and level with the hive. My goal for this image was to capture both the beauty and behavior of the sweat bee.

By setting up my camera close to an active ground hive, I was able to document various individuals as they went about their daily foraging activities, capturing egress (bottom left), active flight (facing page, top) and ingress (facing page, bottom). To aid in my capture, I pre-focused on the tip of a pencil that I placed at the hive's entrance and within the flight path. Shooting with a fast shutter speed of $^1/_{1000}$ second was critical in capturing the action of these subjects.

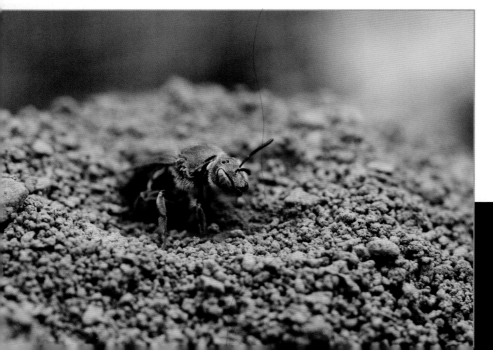

TECH SPECS ►

- Nikon D7000 body
- Nikon AF-S VR Micro-Nikkor 105mm lens
- f/5.6 at 1/1000 second, ISO 400
- Natural light conditions: overcast

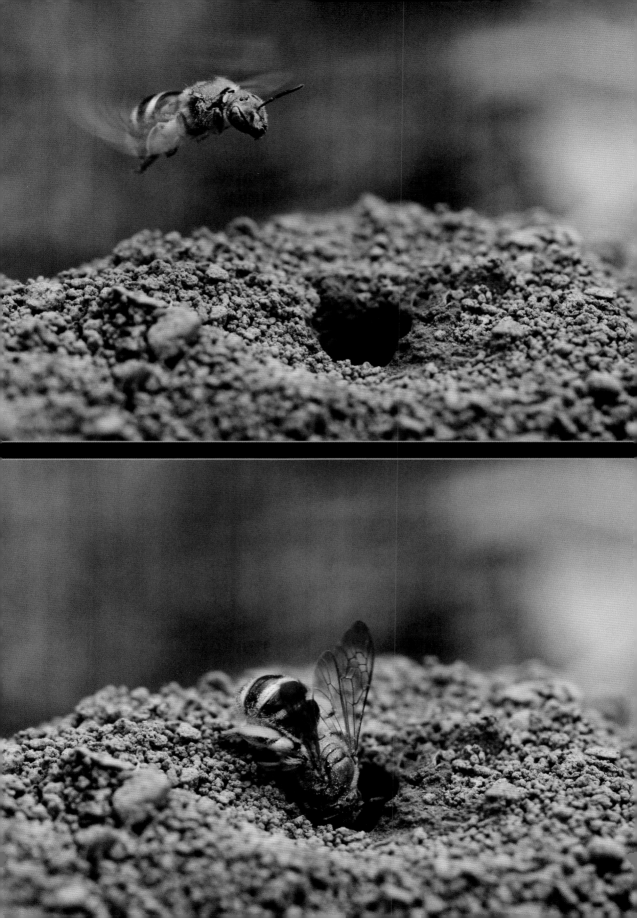

21. Advantage of Morning Shoots

Bee Fly ■ Family *Bombyliidae*

The larvae of many bee flies are known parasitoids, a behavior like parasitism, except the host is killed and consumed in the process.

Understanding Your Subject

Adult bee flies are pollinating insects with long, highly adapted probosces specialized for acquiring nectar. Their common name

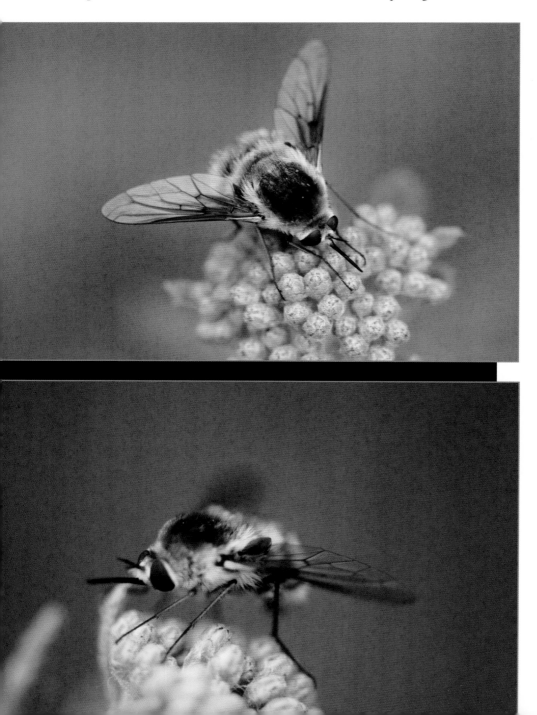

is attributed to their slight resemblance to bumblebees, but what distinguishes them in the order *Diptera* (True Flies) is their single pair of membranous wings.

Locating Your Subject

Bee flies are commonly encountered in open fields, meadows, and backyard gardens, hovering around flowers. They typically rest in open sandy areas on the ground.

Shooting Your Subject & Photographic Process

The image below was shot from a tripod with the camera positioned at a distance of 1 foot and on a level plane with the subject.

Getting close enough to a bee fly for macrophotography is notoriously difficult. In this case, I was fortunate to find one resting on a yarrow flower in my backyard garden. As I began to shoot, I quickly realized the evening light had diminished beyond levels suitable for photographing (facing page, bottom). Instead of disturbing this subject with artificial lighting, I gambled on the fact that it was likely to spend the night in the same resting spot.

Sure enough, the next morning I was elated to find my subject still on the yarrow flower. The softly glowing morning light made all the difference in capturing its intricate detail (below). In addition, the sun had yet to warm the bee fly, rendering it motionless for the duration of the shoot.

TECH SPECS ▼

- Nikon D7000 body
- Nikon AF-S VR Micro-Nikkor 105mm lens
- f/8 at 1/90 second, ISO 400
- Natural light conditions: sunny

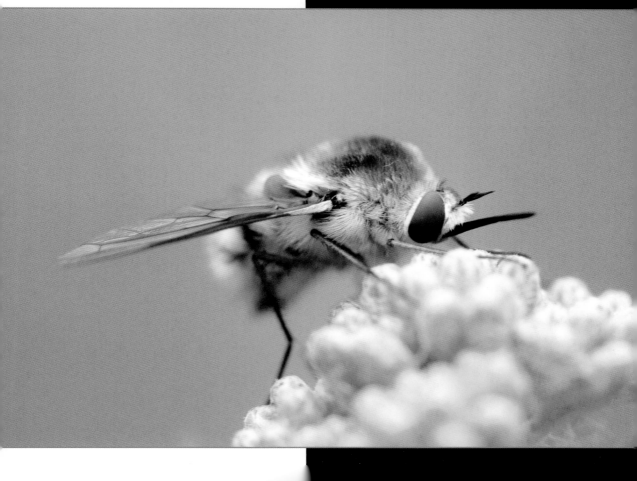

22. Sun Position
Grasshoppers ■ Family *Acrididae*

Grasshoppers in the family *Acrididae* are often recognized as locusts, a name given to them when they congregate in massive swarms.

Understanding Your Subject

Grasshoppers have two pairs of wings. The forewing (or tegmina) is narrow and protects the membranous hind wings used for flight. They feed primarily on vegetation and have an affinity to grasses.

Locating Your Subject

Grasshoppers are easy subjects to locate, as they are often seen in open fields and meadows. Grasshoppers are easily startled and often require a stealthy approach to get close enough for macrophotography.

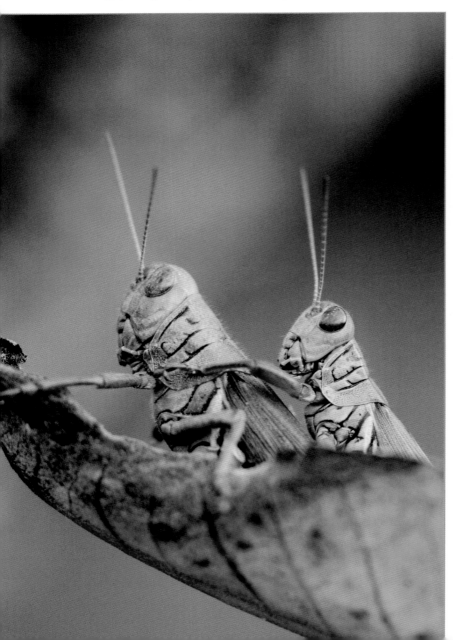

Shooting Your Subject & Photographic Process

These images were shot from a tripod with the camera positioned 1.3 feet away from the subjects and on a level plane with them.

The two individuals were located late in the day, just prior to the sun dropping below the horizon. The low light conditions made for a technically challenging shoot. I had to increase my ISO to 800 to provide the amount of light needed. I could have pushed it to ISO 1600, but I often find the noise at this level to be overly distracting.

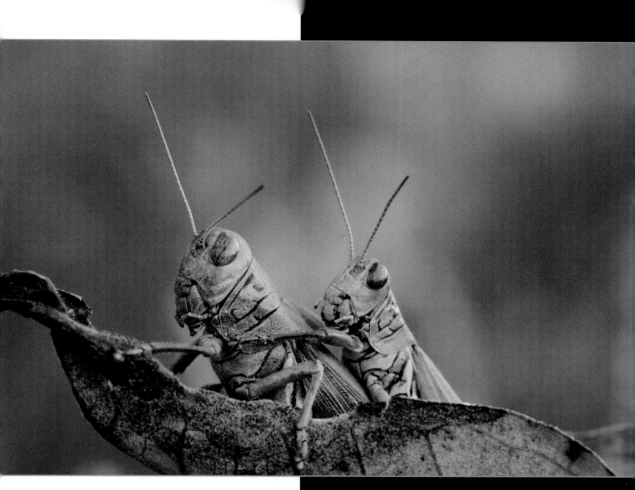

Because I was shooting on a calm night with still subjects, I was able to photograph from my tripod at a very slow shutter speed of $1/10$ second. By positioning the sun behind me (as seen in the diagram), I was able to maximize the remaining sunlight instead of attempting an image from the shadowed side of these subjects.

I also adjusted my original camera position from vertical (facing page) to horizontal (above). This allowed me to capture more of the leaf periphery, selectively framing these two subjects.

TECH SPECS ▲

- Nikon D7000 body
- Nikon AF-S VR Micro-Nikkor 105mm lens
- f/11 at 1/10 second, ISO 800
- Natural light conditions: sunny

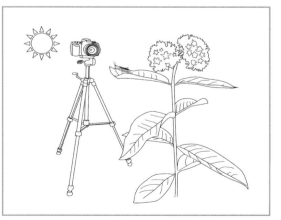

23. Identifying Distracting Elements

Plume Moth ■ Family *Pterophoridae*

Although closely related, moths differ from butterflies by having plume-like or saw-edged antenna. Butterfly antenna, in contrast, are club-like in shape. Behavioral differences are also distinguishing; where moths are mostly nocturnal, butterflies are mostly diurnal.

Understanding Your Subject

Plume moths are alien in appearance. They rest with their wings extended and rolled up, giving them their characteristic T-shaped silhouette. Active primarily at night, individuals can be observed at pollinating sources during the day.

Using a Tripod

I often shoot from a tripod even when conditions allow for hand-held photography. I do this because it allows me to remain relatively motionless, reducing the likelihood of scaring off the subject.

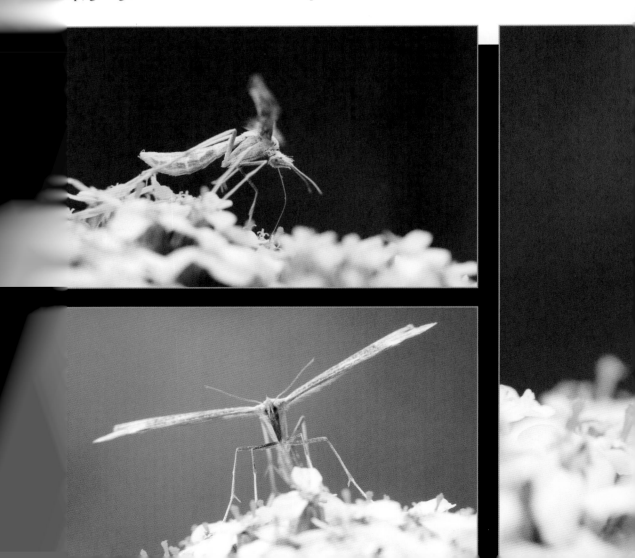

Locating Your Subject

Plume moths can be difficult to locate. They often blend in very well with their surroundings and may initially look more like dried plant material than living insects. I most frequently encounter these subjects as they actively pollinate various wildflowers. Concentrate your search efforts in fields, meadows, and other open areas with abundant pollination sources.

Shooting Your Subject & Photographic Process

This image was shot from a tripod with the camera positioned 1.1 feet from the subject and on a level plane with it. I wanted to capture the feeding behavior of this subject as it slowly moved around the flower head, constantly coiling and uncoiling its proboscis to feed on the flower's nectar. Capturing this action was tricky and required the perfect timing of the shutter release. Ideally, I would have wanted to capture it without the front leg extending behind the coiled proboscis; that leg adds a distracting element to the overall shape and intended image composition.

TECH SPECS ▼

- Nikon D7000 body
- Nikon AF-S VR Micro-Nikkor 105mm lens
- f/11 at 1/250 second, ISO 400
- Natural light conditions: overcast

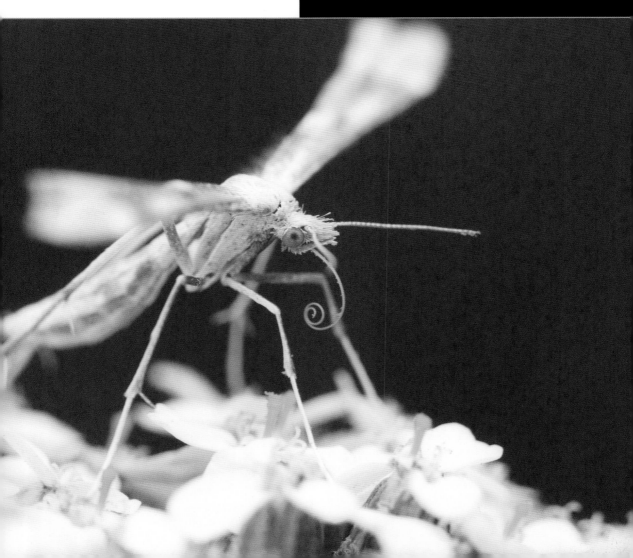

24. Staging in Nature
Eastern-Eyed Click Beetle ■ *Alaus oculatus*

Click beetles are named after a strange behavior they possess. When on their backs and threatened, they quickly spring their heads back, making a loud "click" noise, propelling the beetle into the air.

Understanding Your Subject
Eastern-eyed click beetles are one of the largest species of click beetle, reaching lengths of almost 2 inches. They have two large false eyespots on their pronotum that are thought to scare off potential predators.

Return Your Subjects
When staging wildlife in nature, always return the subject to the exact spot it was located. Try not to remove subjects from the site where they originated.

Locating Your Subject
Eastern-eyed click beetles are most commonly encountered in deciduous and mixed forest woodlands. Occasionally, they can be located in open habitats, including backyard gardens.

Shooting Your Subject & Photographic Process
The facing-page image was shot from a tripod with the camera positioned 1.3 feet away and at a slight angle to the subject.

I rarely stage my subjects; greater than 90 percent are photographed in the same position in which they were encountered. I find that capturing natural poses leads to better images with more pleasing compositions.

In this case, however, I did not have much of a choice. I would not have been able to shoot this subject in the tight quarters where it was found. Moving to a better area, I staged this subject very simply on a stone that was covered in lichen. The beetle happily began crawling around on the stone. All I had to do was reposition the rock to change the beetle's orientation.

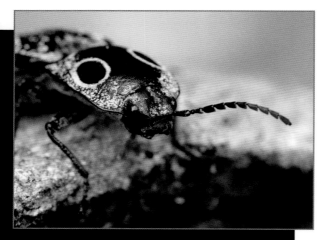

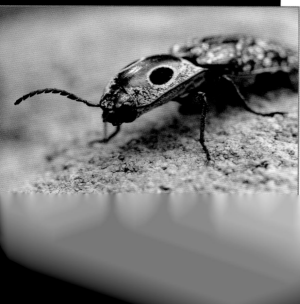

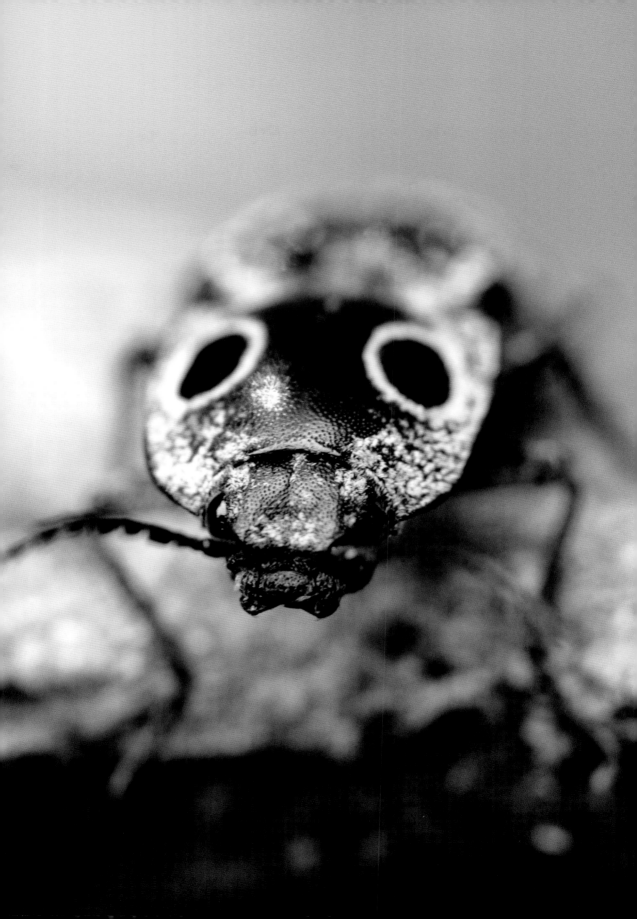

25. Focusing Trick

Great Spangled Fritillary ■ *Speyeria cybele*

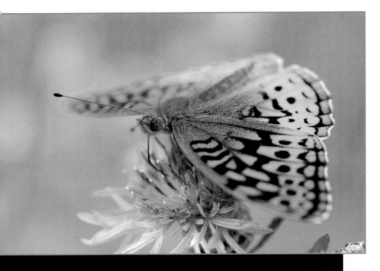

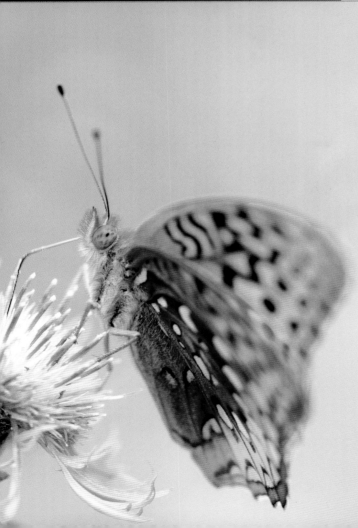

The caterpillars of the great spangled fritillary have a spring emergence synchronized with violet plants, their host species.

Understanding Your Subject

The great spangled fritillary is most commonly seen during the summer and early fall months. A larger species with a wingspan reaching 3 inches, they are sometimes mistaken for their close cousin, the monarch butterfly.

Locating Your Subject

Easily located in fields, meadows, and backyard habitats, fritillaries can be seen fluttering just above the variety of wildflowers on which they feed. They have an affinity toward strong nectar sources, such as milkweeds and thistles, often selectively foraging on only one or two species at a time.

❝ Capturing butterfly images takes patience and a willingness to immerse yourself in the flowers on which they are feeding – in this case, spotted knapweed. ❞

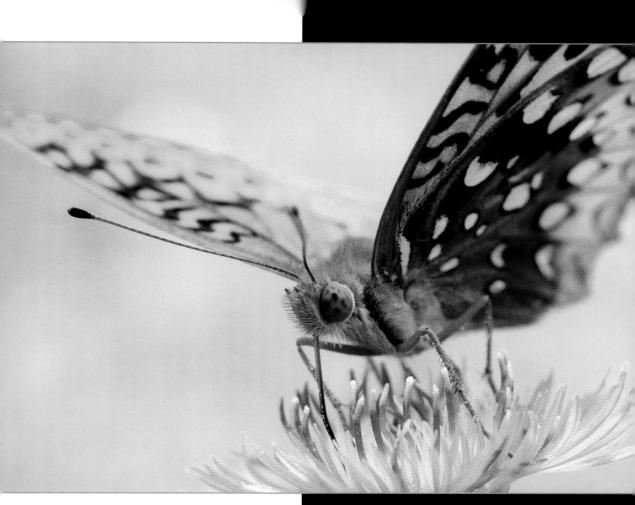

Shooting Your Subject & The Photographic Process

The image above was shot hand-held with the camera positioned 1.7 feet away from the subject and on a level plane with it.

Capturing butterfly images takes patience and a willingness to immerse yourself in the flowers on which they are feeding—in this case, spotted knapweed. I positioned myself within a cluster of these flowers that were growing in an open field and attracting multiple individuals.

I set my camera to focus on one specific flower and waited. After just a few minutes the butterflies returned. Being careful not to shift my position, I only had to move

TECH SPECS ▲

- Nikon D7000 body
- Nikon AF-S VR Micro-Nikkor 105mm lens
- f/6.7 at 1/3560 second, ISO 400
- Natural light conditions: sunny

the camera slightly back and forth to fine-tune the focus. I often use this fixed-focus technique when working with easily startled subjects.

Because I was not reaching for the focus ring, the butterfly wasn't startled by my presence. This allowed me to snap multiple images as she went about her feeding activities.

26. Timing the Bloom
Bloodroot ■ *Sanguinaria canadensis*

The reddish sap of bloodroot was commonly used as a dye by Native Americans and is currently being investigated as a potential treatment for cancer.

Understanding Your Subject
Bloodroot blooms during the early spring, often for a short period of time spanning just a few days. Most commonly encountered in the forest interior, bloodroot can also be observed growing on the edges of woodland habitats.

Locating Your Subject
Bloodroot is not a difficult species to locate. Scan the forest floor on sunny days during the early spring for their blooming white flowers; on cloudy days, the flowers often remain closed. Often, bloodroot is found in patches blanketing the forest floor. If you miss the spring bloom, you can search for the plant's single large-lobed leaf throughout the year. Then, return to the same spot to photograph the flower the following spring.

Shooting Your Subject & Photographic Process
The facing-page image was shot hand-held with the camera positioned at a distance of 1.3 feet and on a level plane with the subject. Timing the bloom was critical for the success of this image. I wanted to capture the bloodroot prior to the brilliance of its fully open bloom, conveying a softness reminiscent of a watercolor painting. To achieve this effect, I photographed on an overcast day at f/3.5, blurring out all but the focal point of the flower. This highlighted the soft whites, yellows, and subtle streaks of light shining through each petal. The monochromatic background color was achieved by surrounding the subject with fallen oak leaves in various shades of light brown.

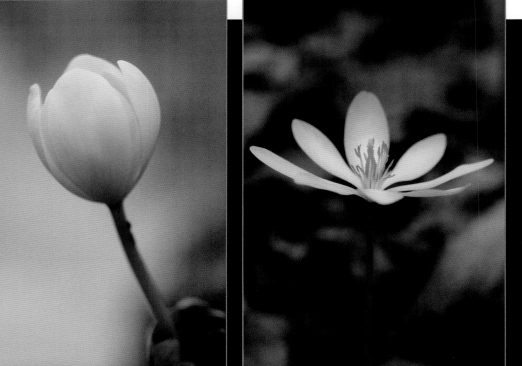

TECH SPECS ▶
- Nikon D7000 body
- Nikon AF-S VR Micro-Nikkor 105mm lens
- f/3.5 at 1/250 second, ISO 400
- Natural light conditions: overcast

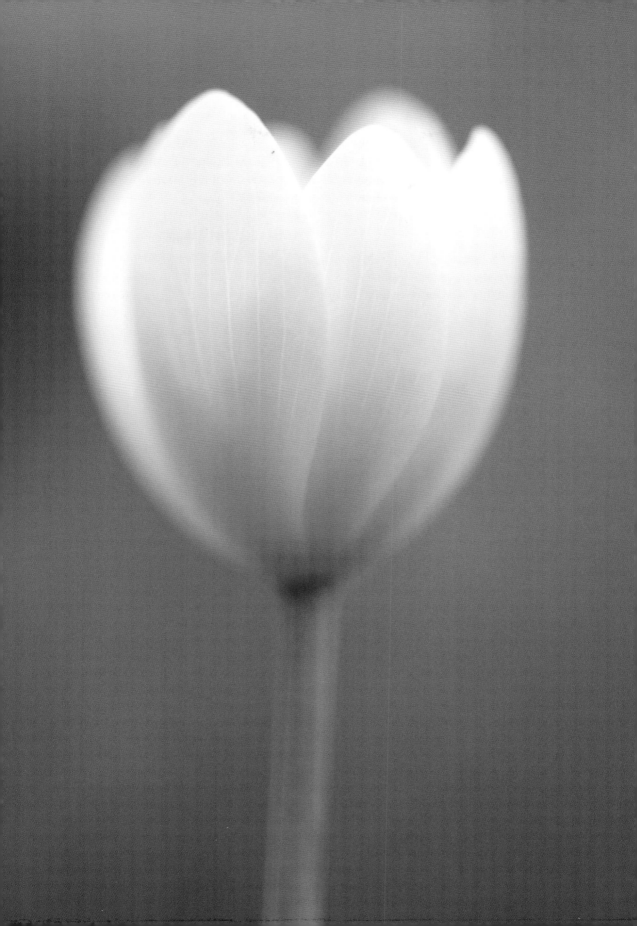

27. Artificial Backgrounds in Nature

Forget-Me-Not ■ *Myosotis scorpioides*

Due to the ability of forget-me-not to form invasive monocultures in sensitive wetland habitats, cultivation in gardens is discouraged until the environmental impacts are better understood.

Understanding Your Subject

Blooming from spring to fall, the forget-me-not is a small herbaceous perennial. Multiple flowers are located on a terminal raceme, their sky blue petals surrounding a yellow center. Young flowers are often pink or even white in color.

Locating Your Subject

Blooming from spring to fall, forget-me-not is commonly encountered within wetland habitats, typically along river, stream, lake,

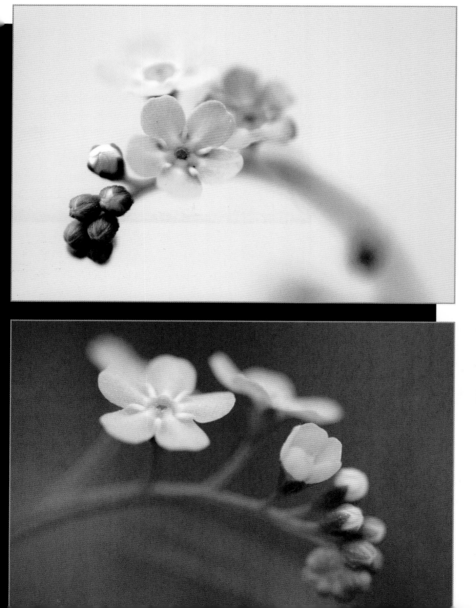

66 One thing I have learned is to be prepared for anything during photography excursions. 99

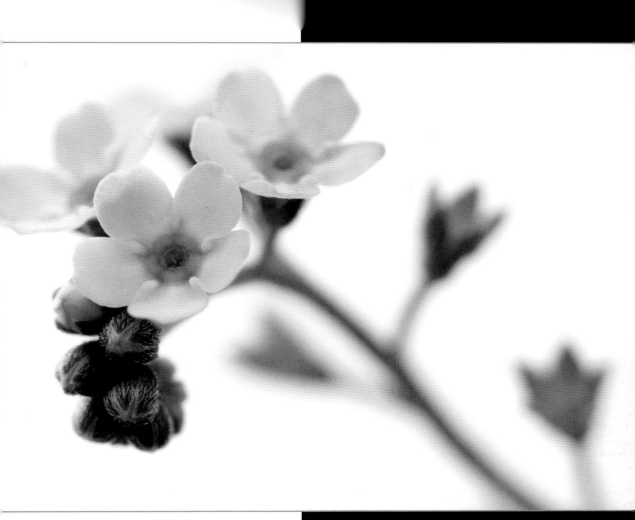

and pond banks where it has escaped cultivation and naturalized across North America.

Shooting Your Subject & Photographic Process

The above image was shot from a tripod with the camera positioned 1.2 feet away from the subject and slightly below it.

Although the image with the green background (facing page, bottom) works in a technical sense, for me it did nothing to capture the delicate nature of this species. I was unable to use the surrounding vegetation or sky to create a visually pleasing background—but one thing I have learned is to be prepared for anything during

TECH SPECS ▲
- Nikon D7000 body
- Nikon AF-S VR Micro-Nikkor 105mm lens
- f/8 at 1/180 second, ISO 400
- Natural light conditions: overcast

photography excursions. I always pack basics in my bag, including 8x10-inch mat boards (in both white and black) to use as artificial backgrounds. While in the field, I was able to create an "in-studio" appearance (above) using the white mat board to softly highlight the glowing and delicate beauty of these flowers.

28. Fading Your Subject

Dutchman's Breeches ■ *Dicentra cucullaria*

As with many plants, ants disperse the seeds of Dutchman's breeches, feeding the fleshy, nutrient-rich elaiosomes to their larvae back at the colony.

Understanding Your Subject

Dutchman's breeches have an irregular flower with two white outer petals and two yellow inner petals. Bearing a slight resemblance to a pair of upside down breeches, the two outer petals contain the flower's nectar,

Look for Fresh Blooms

When photographing delicate flower species like Dutchman's breeches, spend time looking for fresh blooms. These will typically have fewer imperfections, such as brown discoloration, on the petals.

a sweet reward for hard-working pollinating insects.

Locating Your Subject

Dutchman's breeches occur in moist forest habitats within areas of dappled sunlight. As a spring ephemeral, this species can be located in bloom only during a short window of time each spring.

Shooting Your Subject & Photographic Process

The facing-page image was shot hand-held with the camera positioned at a level plane 1 foot from the subject. I positioned the terminal flower as the focal point of the image and let the remaining flowers fade into a blur and become the image background. To accomplish this, I positioned the camera with the raceme nodding into the lens. Experimenting with multiple f-stops, I found f/8 to work best in capturing the details of the terminal flower while still softening, but not losing, the ghostly shapes of the remaining background flowers.

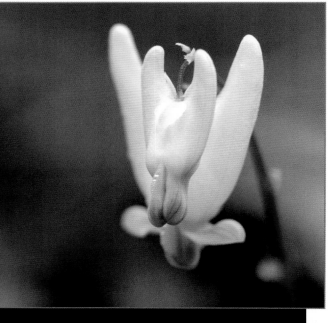

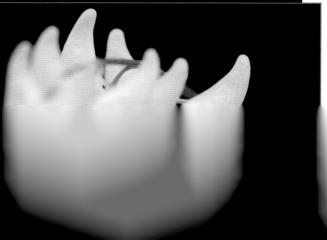

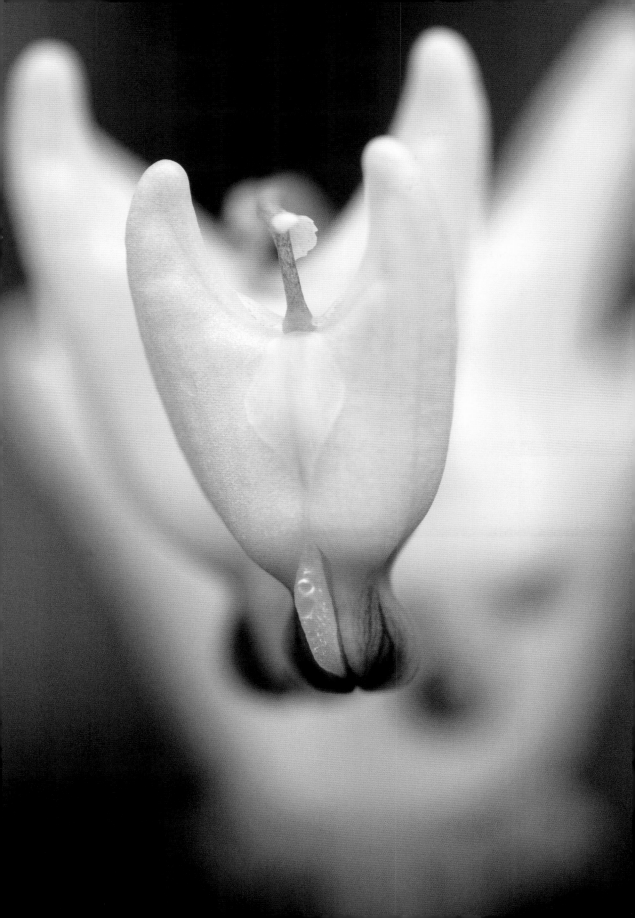

29. Eliminating Distractions

Herb Robert ■ *Geranium robertianum*

The leaves of this plant can be rubbed on the skin to repel biting insects—although you may want to stick with less pungent and commercially available repellents.

Understanding Your Subject

Herb Robert is an annual, reaching heights of just over 1 foot. The small, pink flowers, visible from summer through fall, have five rounded petals, each streaked with white.

Locating Your Subject

Herb Robert is encountered in a variety of habitats, including woodlands; dry, open rock outcrops; and backyard gardens.

Shooting Your Subject & Photographic Process

The final image in this series (facing page) was shot hand-held with the camera positioned at a distance of 1.3 feet and on a slight downward angle to the subject.

This series illustrates the importance of selecting the correct f-stop for your photograph. The first image (bottom left) was shot at f/16 in order to demonstrate clearly how distracting a composition can become when all of the elements are left in focus. Narrowing the depth of field to f/4 (bottom right), I was able to blur many of the distracting elements.

For the final composition, I used a simple trick to eliminate the distraction of the protruding stem behind the focal flower: I gently bent it down and taped it in place. I finalized the composition with a minor crop, fully isolating the focal flower in the frame.

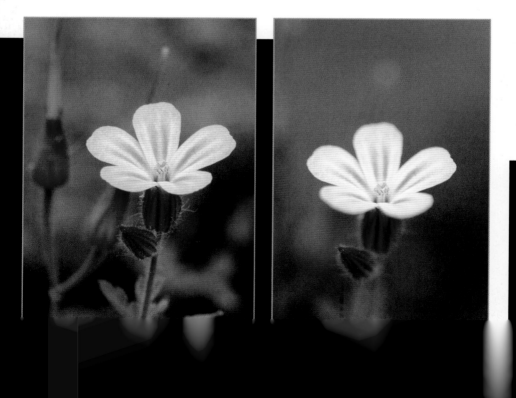

TECH SPECS ▶

■ Nikon D7000 body
■ Nikon AF-S VR Micro-Nikkor 105mm lens
■ f/4 at 1/180 second, ISO 200
■ Natural light conditions: overcast

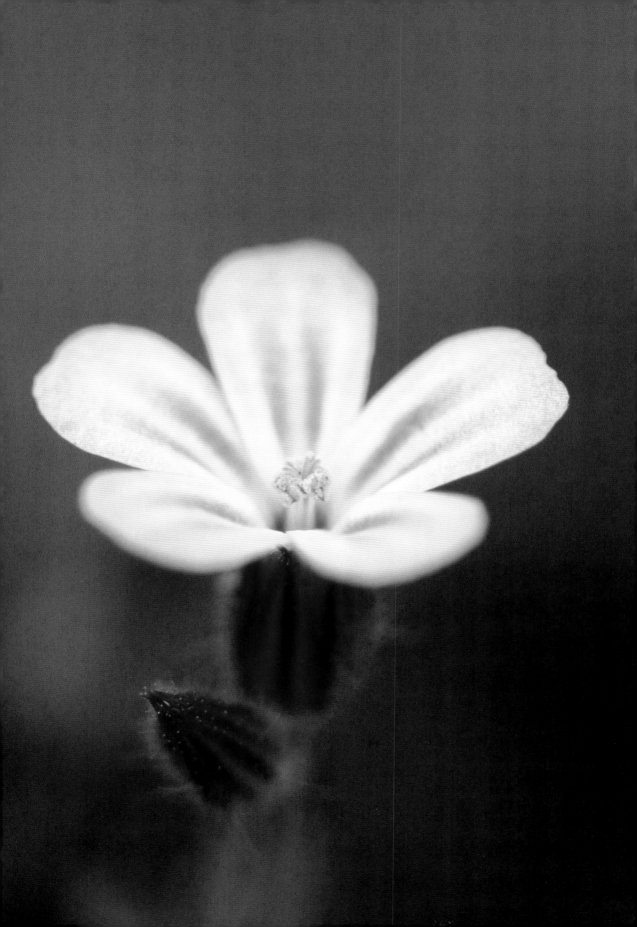

30. Side Unseen

Oxeye Daisy ■ *Leucanthemum vulgare*

Appearing as one flower, daisies are actually a composite of many tiny flowers where only the marginal flowers have petals.

Understanding Your Subject

The Oxeye daisy is a herbaceous perennial that commonly reaches heights of 1 to 3 feet. Native to Europe and Asia, they have been introduced to North America where they are often considered an invasive weed.

Locating Your Subject

Oxeye daisies occur in a variety of habitats and are commonly encountered blooming in fields, meadows, and roadsides throughout the summer months. The yellow center surrounded by white petals makes them easily distinguishable in a field of flowers.

Shooting Your Subject & Photographic Process

The facing-page image was shot lying on the ground, with the camera hand-held and positioned 1.8 feet away from the subject on a steep upward angle of approximately 45 degrees. This angle was chosen to break up the white background of clouds with a green row of trees positioned along the image horizon, echoing the curve of the flower.

By experimenting with various shooting angles, I was able to capture the more interesting underside of composite flowers—the side unseen. Highlighting the whorled bracts of the flower's underside abstractly captures the beauty of the Oxeye daisy. Adding to the mood of this image is the monochromatic play between the white clouds and the petals, which further accentuates the greens and yellows of the bracts.

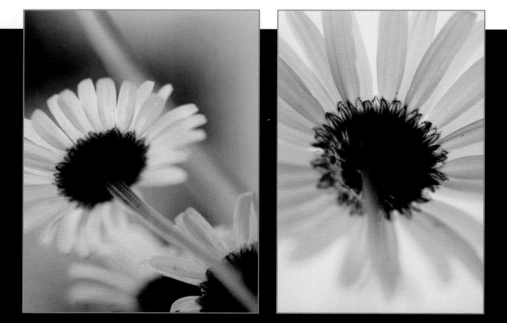

TECH SPECS ▶

- Nikon D7000 body
- Nikon AF-S VR Micro-Nikkor 105mm lens
- f/4 at 1/250 second, ISO 400
- Natural light conditions: overcast

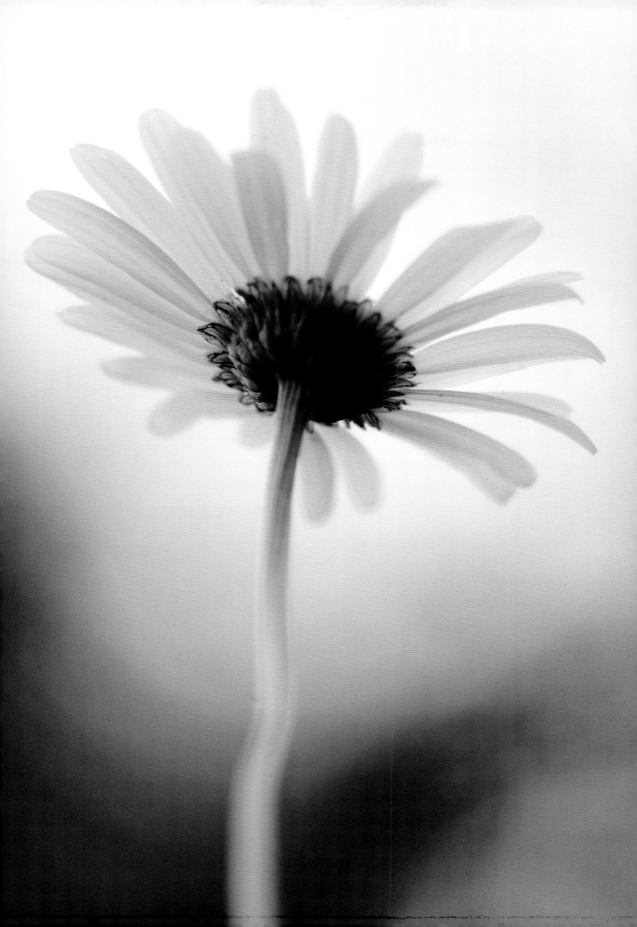

31. Subtle Beauty
Rosette Grass ■ *Dichanthelium* sp.

The similarities between the 72 described species of *Dichanthelium* grasses make identification to the species level especially challenging.

Understanding Your Subject
Dichanthelium grasses are flowering plants that produce chasmogamous flowers in the spring and cleistogamous flowers later in the season. This means that the early season flowers open and undergo cross-fertilization, exchanging pollen with other individuals of the same species, while the late season flowers never open and are self-fertilizing.

Locating Your Subject
Rosette grasses can be found year-round in a wide variety of natural habitats, including forests, meadows, river and lake shores, and areas impacted or created by humans.

Shooting Your Subject & Photographic Process
The facing-page image was shot from a tripod with the camera positioned at a distance of 1.1 feet and on a slight downward angle

Slow Down
This is one of the images that truly opened my eyes to the beauty of macrophotography. Traditionally unassuming, this grass taught me to slow down and let the macro world open up to me instead of trying to chase it down.

to the subject's inflorescence. At this angle, I was able to capture the delicate lines of the individual spikelets leading to the terminal floret. I positioned the grass diagonally through the focal point in my frame, tilting the base away from my lens. These two angles add dimension by balancing the sharpness and softness within the image. Together, they weave the viewer's eye back and forth around the subject and overall composition.

TECH SPECS ▶
- Nikon D7000 body
- Nikon AF-S VR Micro-Nikkor 105mm lens
- f/13 at 1/30 second, ISO 400
- Natural light conditions: overcast

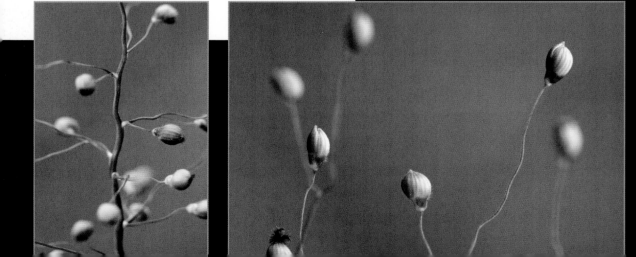

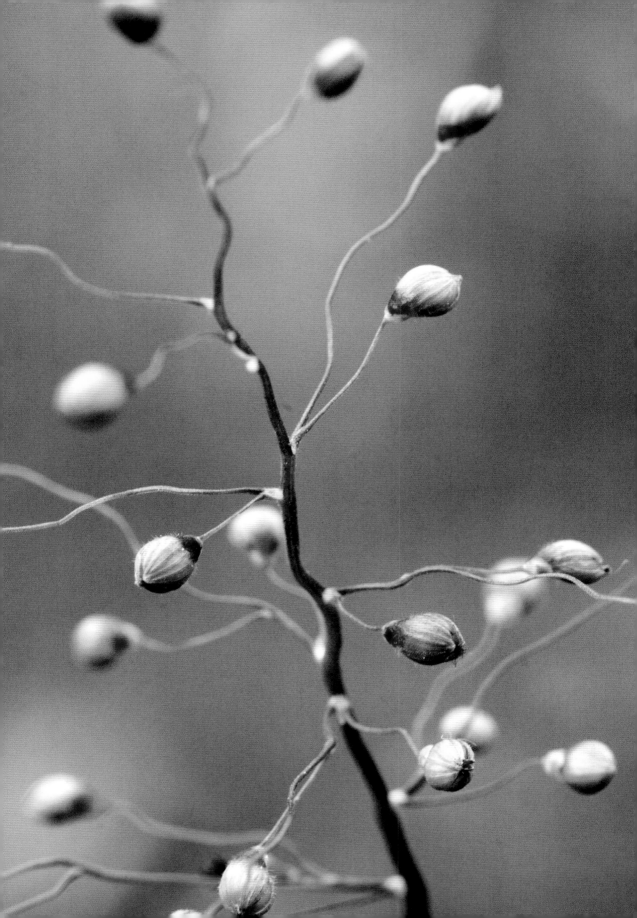

32. Shooting in Dappled Sunlight
Round-Lobed Hepatica ■ *Anemone americana*

Round-lobed hepatica is named for its three-lobed leaf, which resembles the liver in shape.

Understanding Your Subject
Round-lobed hepatica is one of the first species to flower in the early spring. Ranging in color from dark purple, to pink, to white, the flowers display six to twelve petals. They have hairy stalks that typically grow in small clusters within open areas of forest canopies.

Locating Your Subject
Search for blooming round-lobed hepatica during the late winter/early spring, as the last of the winter's snow melts away. Concentrate your efforts in mixed deciduous forests with oak, beech, and maple trees.

Shooting Your Subject & Photographic Process
This image was shot hand-held with the camera positioned 1.5 feet away from and on

Create a Shadow
Shooting on sunny day while under a forested canopy often creates distracting lighting conditions. To eliminate dappled lighting, I often use a small piece of mat board mounted to a stick with binder clips to cast a soft shadow over my subject.

a level plane with the subject. In this composition, I wanted to highlight the flowers in their various stages of bloom. I accomplished this by using a medium aperture of f/6.7. This allowed me to blur the vegetation in both the foreground and background, effectively framing the subject and giving the image an overall softness reminiscent of a watercolor or pastel painting. To achieve the delicate framing, it was critical to remove the excess dead leaves and debris within the point of focus until the desired softness was achieved.

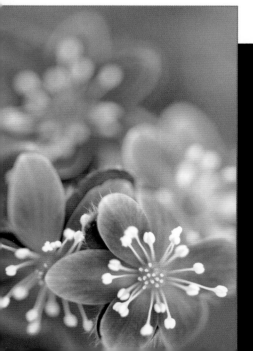
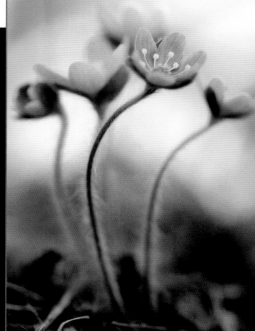

TECH SPECS ▶
facing page

- Nikon D7000 body
- Nikon AF-S VR Micro-Nikkor 105mm lens
- f/6.7 at 1/180 second, ISO 400
- Natural light conditions: sunny, shot in shade

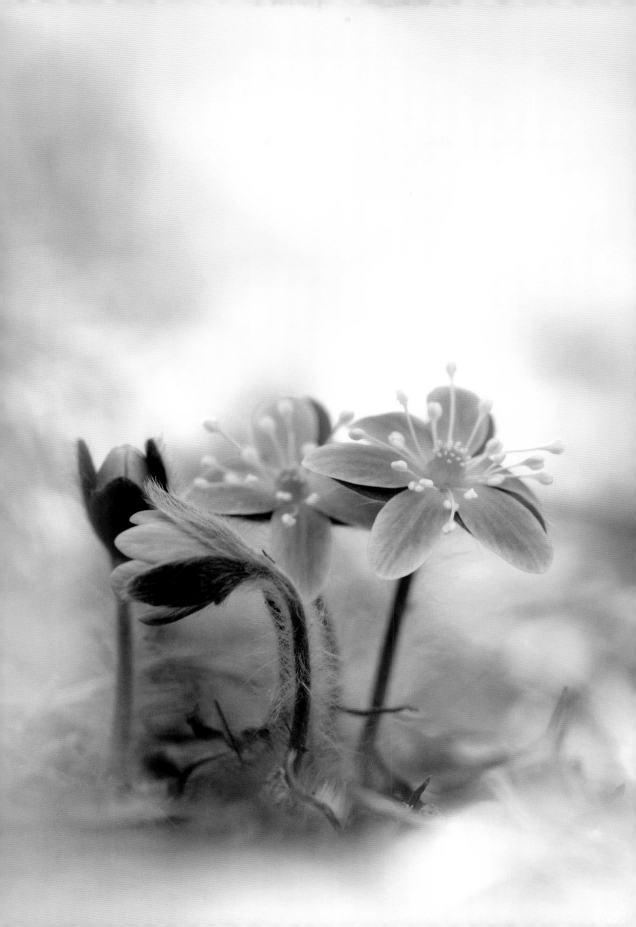

33. Isolating Subjects
Siberian Squill ■ *Scilla siberica*

Siberian squill was introduced to North America as an ornamental flower. Escaping cultivation, this species is often considered an invasive plant.

Understanding Your Subject
Siberian squill is a small species, often not exceeding 6 inches in height, with a raceme containing multiple flowers. Serving little ecological function outside its native Russian range, the Siberian squill is cold resistant and often untouched by native herbivores. The cultivation of such non-native species with invasive tendencies is discouraged.

Locating Your Subject
Easily encountered during the early spring, Siberian squill is often found in close proximity to the parent garden where it was cultivated. Escaped colonies can often be observed blanketing natural areas.

Isolating Flowers
When isolating flowers, use small branches stuck in the ground to shift the unwanted plant parts out of the desired field of view. If performed slowly and gently, this technique rarely causes damage to the plant.

Shooting Your Subject & Photographic Process
The facing-page image was shot hand-held with the camera positioned slightly to the left of the subject's center-line and at a distance of 1 foot. Isolating a single flower clearly highlighted the blue petals and stamens instead of watering down these delicate details in a multi-flower composition (bottom right). This image is further focused through the use of f/4.8, crisply highlighting some of the stamen and petals while allowing the others to fade into the green background of the surrounding vegetation.

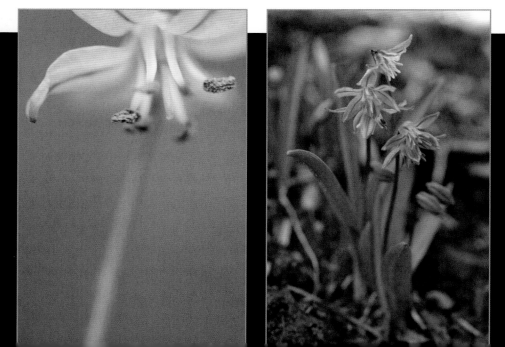

TECH SPECS ▶
facing page

- Nikon D7000 body
- Nikon AF-S VR Micro-Nikkor 105mm lens
- f/4.8 at 1/60 second, ISO 100
- Natural light conditions: sunny, shot in shade

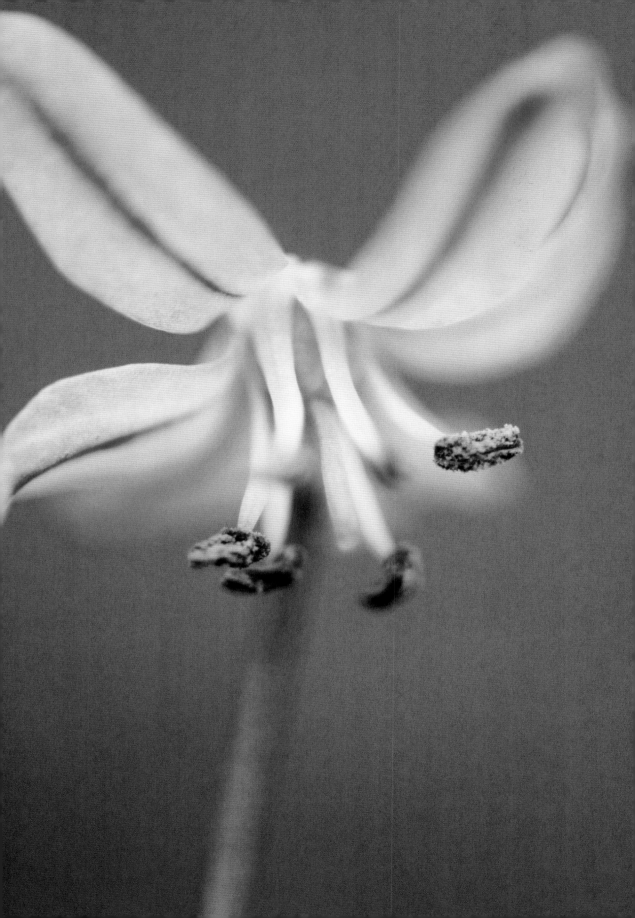

34. Landscape Position
Common Snowdrop ■ *Galanthus nivalis*

Although the flowers and bulbs of snow-drops are toxic, the extracted alkaloid, galanthamine, can be used to manage mild symptoms of Alzheimer's disease.

Understanding Your Subject
Snowdrops are a perennial species, blooming from late winter to early spring. Typically less than 6 inches in height, the white six-petal flower is shaped like bell, hanging from the end of a leafless stalk.

Locating Your Subject
A cultivated species, snowdrops are commonly grown in gardens and can often be seen sprouting from lawns within proximity. Snowdrops can also be encountered in woodlands and meadows where they have escaped cultivation and become naturalized.

Shooting Your Subject & Photographic Process
The image on the facing page was shot hand-held with the camera positioned 1.2

Photo Tip
When searching for subjects to photograph, use micro-topographic landscape features to your advantage to obtain images, angles, and backgrounds that would otherwise not be possible to shoot.

feet away from the subject. The camera was tilted at a slight upward angle, allowing the sky and surrounding vegetation to serve as the image background. Due to the low height of snowdrops, shooting the flower from below is often difficult. This subject happened to be positioned on a slope, allowing me to capture the flower from an unusual angle that highlights the beautiful curvature of the stem giving rise to the bell-shaped flower. Slightly angling the subject in the frame adds interest and facilitates a subtle break between the horizon line and the surrounding vegetation.

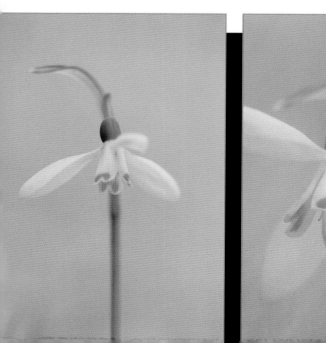

TECH SPECS ►
facing page

- Nikon D7000 body
- Nikon AF-S VR Micro-Nikkor 105mm lens
- f/13 at 1/125 second, ISO 400
- Natural light conditions: sunny, shot in shade

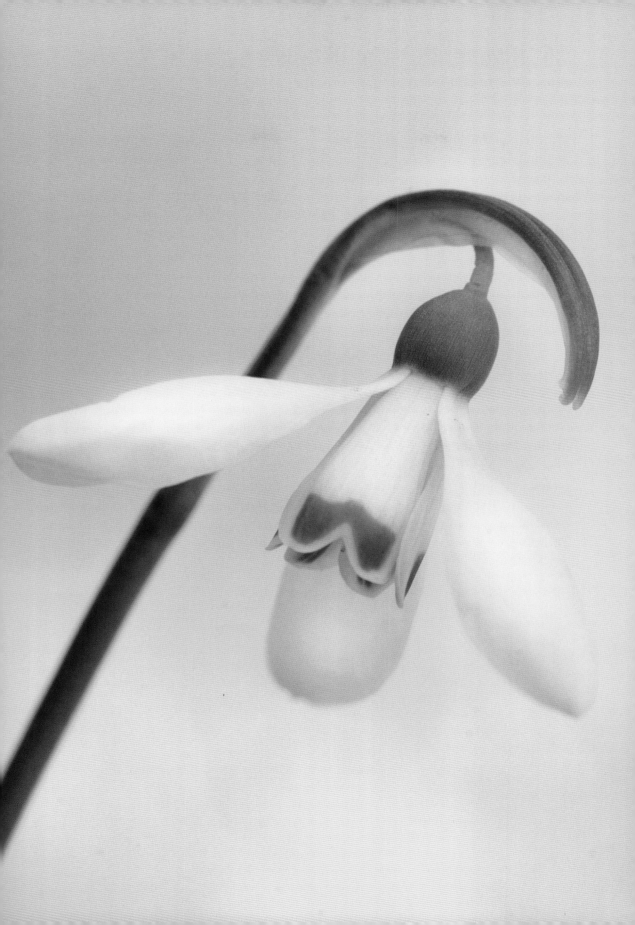

35. Highlighting the Details

Pink Lady's Slipper ■ *Cypripedium acaule*

For seed germination and growth, pink lady's slippers require a specialized fungal species to provide water and nutrients to the developing plant.

Understanding Your Subject

Belonging to the orchid family, the pink lady's slipper is a complex wildflower distinguished and named for its slipper-shaped labellum. This pouch-like structure traps pollinators, typically bumblebees, requiring them to escape the flower through a small opening past the staminode. In their escape, the plant "tricks" them into collecting and depositing pollen for fertilization.

Locating Your Subject

Pink lady's slippers occur in forested and occasionally road-side habitats with acidic soil conditions. Tolerant of both dry and moist deciduous and coniferous forests, they are frequently encountered in shady areas under pine and hemlock stands.

Shooting Your Subject & Photographic Process

The facing-page image was shot from a tripod and on a level plane with the subject; the camera was slightly to the right and at a distance of 1.2 feet. Instead of photographing the full plant, I wanted to highlight the delicate intricacies of the blossom. To accomplish this, I filled the frame with a small portion of the flower. This allowed me to capture the fine details of the hair-like structures while incorporating enough of the pink-streaked labellum to assure the species was still recognizable to the viewer. Due to the dark forest conditions and wide depth of field required to capture the range of detail, I had to use a slower shutter speed. This required timing my shutter release with calm, windless periods.

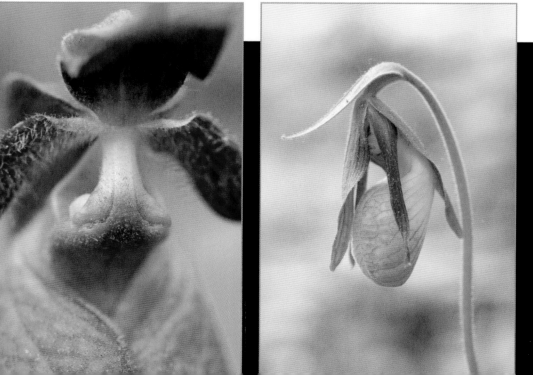

TECH SPECS ▶
facing page

■ Nikon D7000 body
■ Nikon AF-S VR Micro-Nikkor 105mm lens
■ f/9.5 at 1/30 second, ISO 400
■ Natural light conditions: overcast

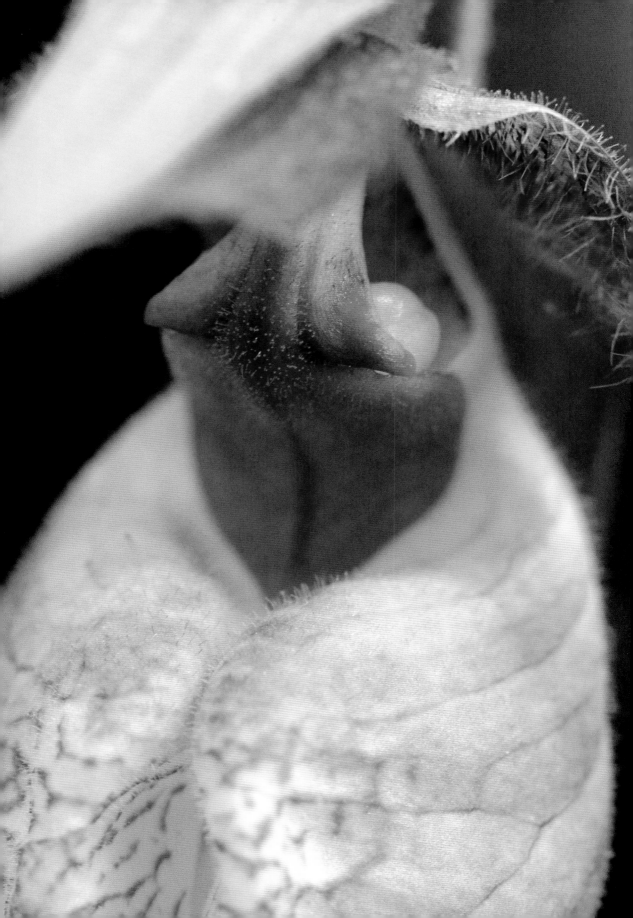

36. Lines in Nature
Bittersweet Nightshade ■ *Solanum dulcamara*

A lthough much less toxic than its close relative deadly nightshade *(Atropa bella-donna)*, bittersweet nightshade is capable of severe poisoning in pets and children who ingest the berries.

Understanding Your Subject
Introduced and widespread across North America, bittersweet nightshade is a perennial vine with beautiful star-shaped flowers comprised of purple petals that often point

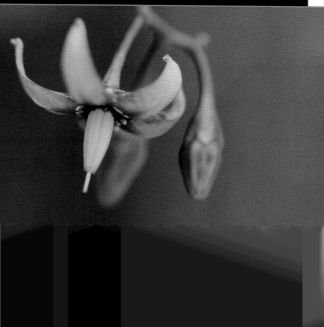

backwards around a fused yellow stamen cone.

Locating Your Subject
Bittersweet nightshade is commonly found in a variety of habitats and along habitat edges, including backyards, woodlands, and wetlands—as well as urban landscapes.

Shooting Your Subject & Photographic Process
The facing-page image was shot from a tripod with the camera positioned on a level plane and 1.5 feet away from the subject.

I wanted to give a ghostly appearance to the beautiful lines of the flower cluster. Using f/4.8 to soften any sharp angles, I was able to focus the image on the bloom, capturing and accentuating the curving lines within the branching flower cluster. The stem softly trails into the background vegetation, creating brilliant leading lines as it fades away from the viewer.

The developmental stages add interest to the composition, highlighting the various shapes and sizes of the bud, the full bloom flower, and the immature berry.

TECH SPECS ►
■ Nikon D7000 body
■ Nikon AF-S VR Micro-Nikkor 105mm lens
■ f/4.8 at 1/250 second, ISO 400
■ Natural light conditions: overcast

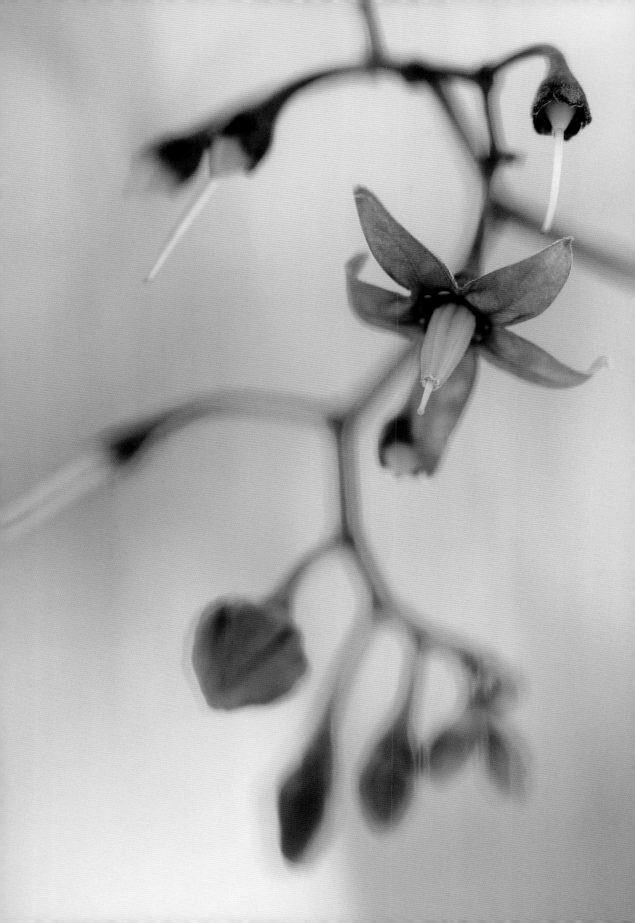

37. Background Color Wash

Blue Cohosh ■ *Caulophyllum thalictroides*

The flowers of blue cohosh occur together at different stages of development to assure pollination.

Understanding Your Subject

Blue cohosh is a perennial wildflower with a small bloom that contains six stamens and a central pistil. It can grow to a height of 3 feet.

Locating Your Subject

Blue cohosh occurs in rich forested landscapes, often along slopes and within ravines. It is often unnoticed due to its small and inconspicuous florescence of greenish-yellow to greenish-purple. Instead, look for its large, compound leaves with lobed leaflets amongst the forest understory.

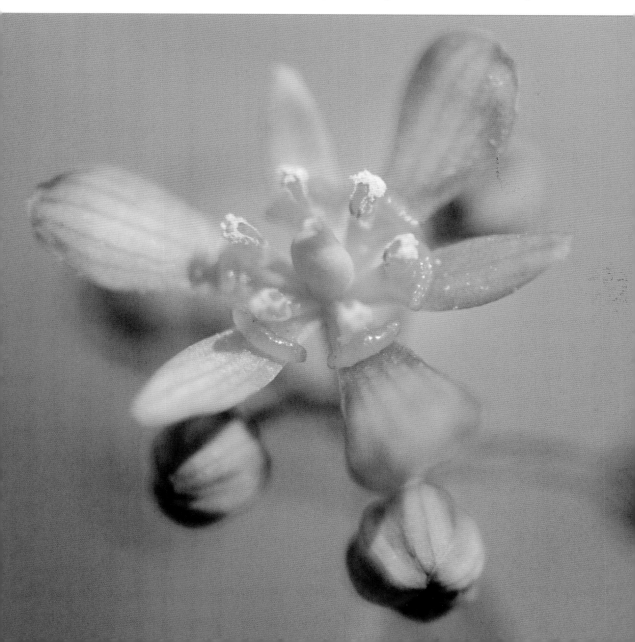

Shooting Your Subject & Photographic Process

The large image below was shot hand-held with the camera positioned at a distance of 1 foot directly above the subject. I began photographing at f/16 and was not pleased with the resulting cluttered detail. Shifting to f/5.6, I was pleasantly surprised to see the background colors wash across the image, almost paralleling the colors of the petals. After experimenting with the subject placement, I was able to capture the green of the leaves fading into the forest floor. The bud's colored stripes encircle the petals' wide-open florescence and add interest to the composition. By shooting from above, I was able to capture the delicate details of a single flower while eliminating the distracting lines of the loosely branched flower cluster.

66 I was able to capture the green of the leaves fading into the forest floor. 99

◄ TECH SPECS
- Nikon D7000 body
- Nikon AF-S VR Micro-Nikkor 105mm lens
- f/5.6 at 1/500 second, ISO 400
- Natural light conditions: sunny, shot in shade

79

38. Creating Soft Compositions

Wild Geranium ■ *Geranium maculatum*

The tannins found in the root of the wild geranium can be used in medicinal teas to treat a variety of ailments.

Understanding Your Subject

Wild geranium is a showy species occurring across the eastern half of North America. On its drooping umbel it produces multiple flowers, ranging in color from light pink to magenta. Dark lines on the petals serve to guide pollinators to the nectaries at the base of the stamens.

Locating Your Subject

Wild geranium is commonly encountered in bloom during the spring and early summer months in forested habitats, meadows, and thickets.

Shooting Your Subject & Photographic Process

The image on the facing page was shot hand-held with the camera positioned 1.1 feet away from the subject and at a slightly elevated angle. As a biologist, I favor images with selective focus, which better represents how the human eye sees nature. When a macro image is entirely in focus, my eyes often jump around, failing to be guided to a focal point. The wild geranium is the perfect subject to illustrate this eye-pleasing technique. At f/4.5, I was able to hone in on few anthers of the flower while blurring the remaining anthers and petals into the background, creating a very soft transition. This guides the eye right to the particular flower structures I was intending to highlight without overstimulating the viewer.

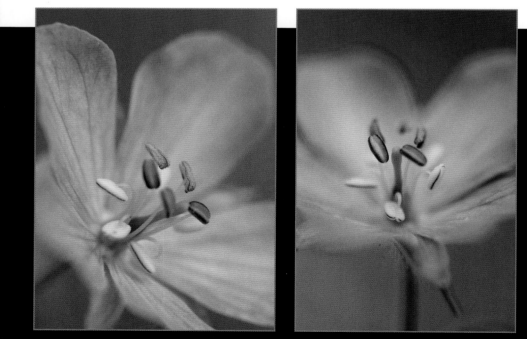

TECH SPECS ▶

- Nikon D7000 body
- Nikon AF-S VR Micro-Nikkor 105mm lens
- f/4.5 at 1/350 second, ISO 400
- Natural light conditions: sunny, shot in shade

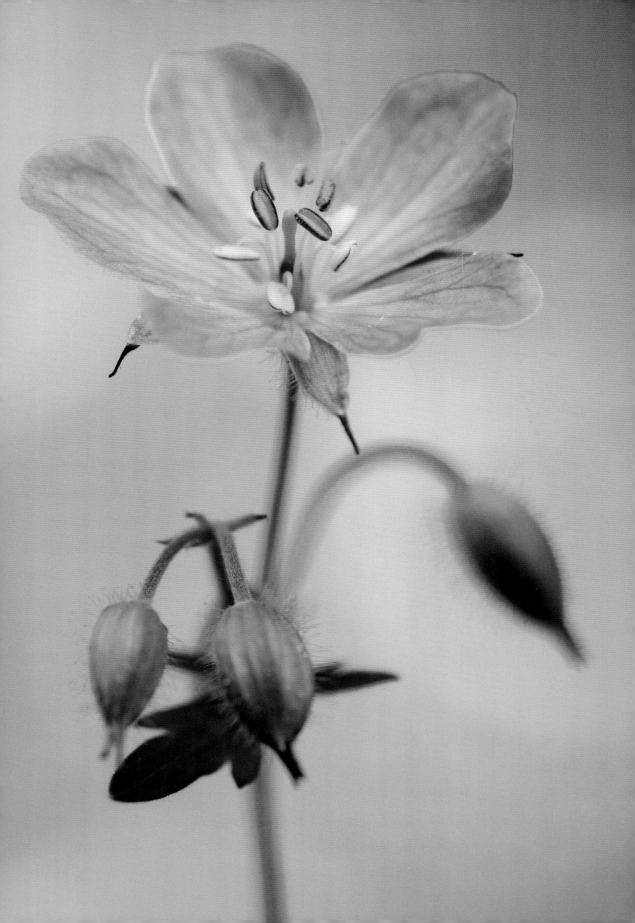

39. Complementary Backgrounds

Deptford Pink ■ *Dianthus armeria*

Deptford pink is named after a suburb of London, where (ironically) it does not occur. It was misidentified and named by botanist Thomas Johnson, who likely confused it with the similar maiden pink.

Understanding Your Subject

Deptford pink escaped cultivation and successfully naturalized across much of North America. Growing in small clusters of three to five flowers, this subject's delicate pink florescence contains five toothed petals adorned with small white spots.

Locating Your Subject

Deptford pink can be found flowering during the late spring and summer months in dry open fields, pastures, and roadsides, as well as within urban landscapes.

Shooting Your Subject & Photographic Process

This image was shot hand-held with the camera positioned 1 foot from the subject and on a level plane with it. Stumbling across this bloom, I quickly knew that I wanted to highlight the pink flowers against the complementing green background. I positioned my camera so the background would consist of only green vegetation, eliminating any other distractions. Being aware of subtle details like these can help maximize the full potential of your color palette, yielding a stable and visually pleasing image.

TECH SPECS ▶
- Nikon D7000 body
- Nikon AF-S VR Micro-Nikkor 105mm lens
- f/3.8 at 1/350 second, ISO 400
- Natural light conditions: overcast

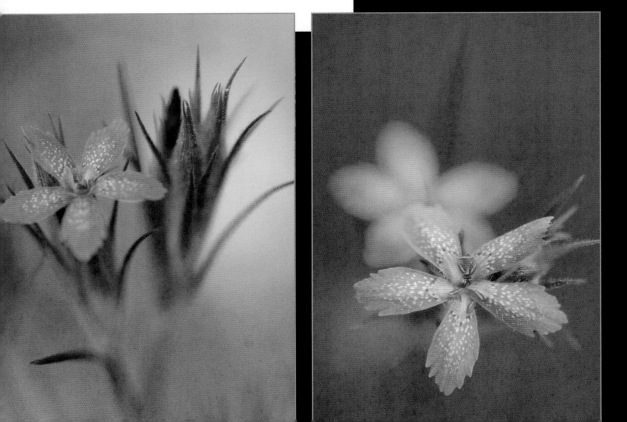

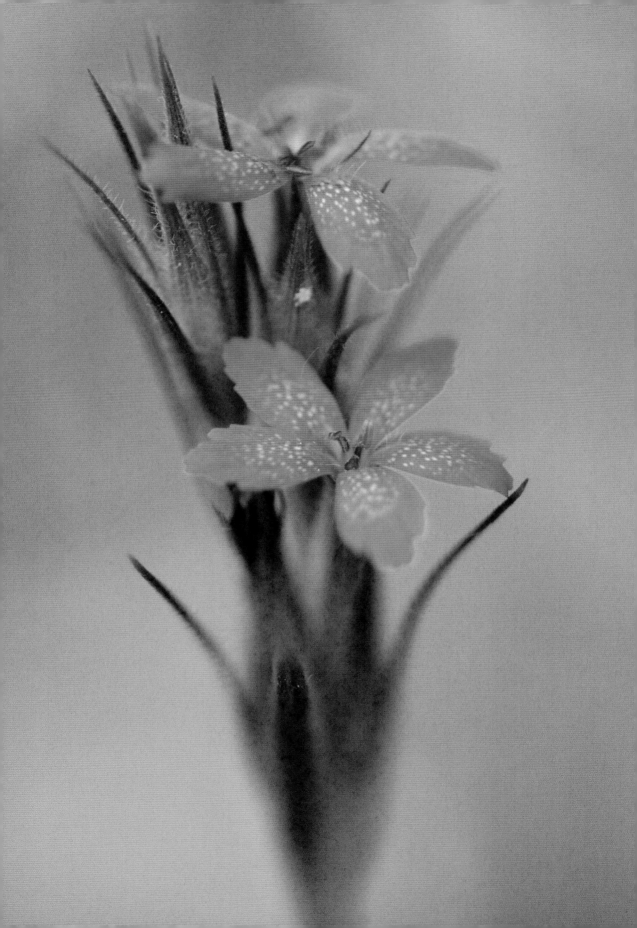

40. One Week, Big Difference
Wood Anemone ■ *Anemone quinquefolia*

The wood anemone does not have true petals, instead it has sepals that take on the appearance of flower petals.

Understanding Your Subject
Wood anemone is a small, delicate spring-time flower with palmately compound leaves in a whorl around the stem. In some individuals, the early foliage is dark in color with a beautiful magenta highlight along the fringe.

Locating Your Subject
Wood anemone is commonly encountered in bloom between March and June in forested habitats and thickets across the eastern half of North America.

Shooting Your Subject & Photographic Process
I shot the facing-page image while lying on the ground with the camera hand-held. I was positioned 1.3 feet away from the subject

Calm Days
When working with delicate species like wood anemone, shoot on calm days to minimize the effects that wind can have on the subject's motion.

and on a level plane with it. By timing this image for the early stages of growth, I was able to capture the species in its most vibrant color. I limited the focal point by using an aperture setting of f/3.5, establishing a visual connection between the bloom and foliage. This also blended the beautiful magenta leaf fringe into the background. The nodding flower erupts from the image background via the rounded stalk, which adds a soft leading line to the overall composition. The surrounding oak leaves serve as a beautiful monochromatic backdrop, further accentuating the leaf margins and bloom.

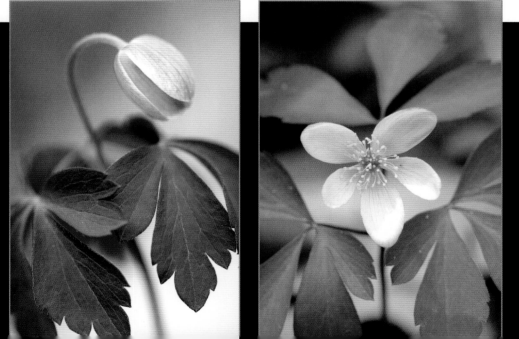

TECH SPECS ▶

- Nikon D7000 body
- Nikon AF-S VR Micro-Nikkor 105mm lens
- f/3.5 at 1/350 second, ISO 400
- Natural light conditions: overcast

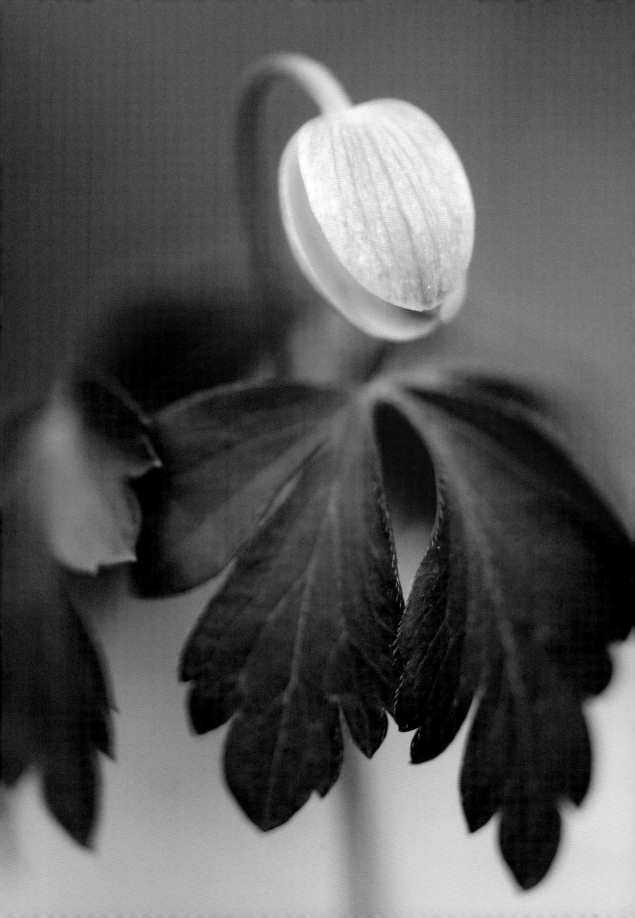

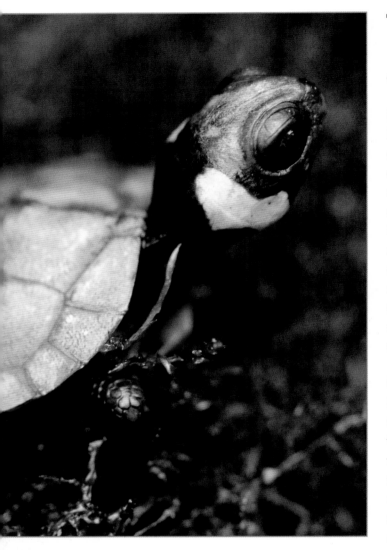

The federally threatened bog turtle is one of the world's most imperiled species of turtle, marginally staving off extinction.

Understanding Your Subject

Bog turtles have a localized regional distribution, inhabiting specialized calcareous wetlands, including wet meadows, bogs, and marshes. They are protected range-wide under the United States Endangered Species Act, making photographing them without proper state and federal permits next to impossible. Fortunately, most other species of hatchling turtles make excellent and accessible photography subjects, as well.

Locating Your Subject

Hatchling turtles are readily encountered along the margins of various wetland habitats, including open-water ponds and lakes. Carefully look through aquatic vegetation, observing any slight movements caused by their small, button-like heads poking out of the water. Often, citizen-scientist opportunities are available for the public, which afford a unique experience

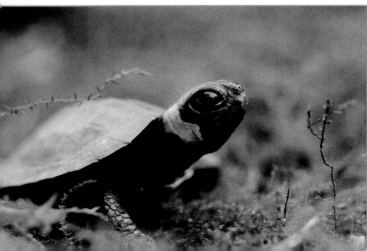

66 Observing and photographing this bog turtle was the opportunity of a lifetime. 99

to work alongside biologists—in addition to opportunities to observe and photograph wildlife for both scientific and artistic purposes.

Shooting Your Subject & Photographic Process

The image below was shot with the camera hand-held on a level plane with the subject and at a distance of 1.3 feet. Although staged, this subject appears natural due to the moss substrate it would usually be observed basking on. As a professional herpetologist, observing and photographing this bog turtle was the opportunity of a lifetime and one of my most memorable career moments. It was important that this image captured both a scientific and artistic expression

⚠ **CAUTION**

While photographing plants and animals, be aware of and abide by state and federal laws governing the protection of imperiled species.

of the individual. This was accomplished by allowing the turtle to relax. It curiously outstretched its head, exposing the beautiful and characteristic orange marking on the side of its neck.

TECH SPECS ▼
- Nikon D7000 body
- Nikon AF-S VR Micro-Nikkor 105mm lens
- f/4.8 at 1/350 second, ISO 400
- Natural light conditions: overcast

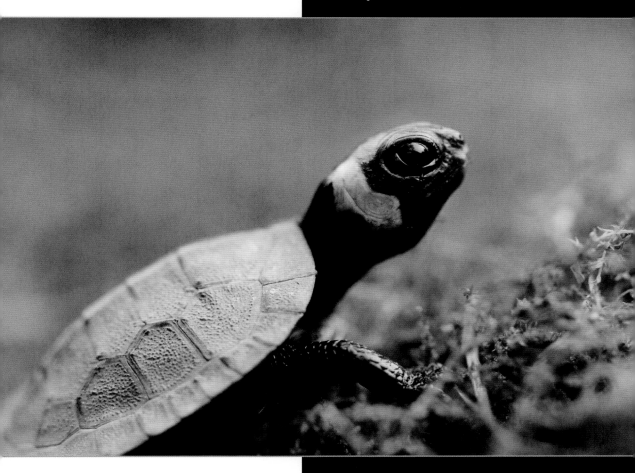

42. Dismal Captures

Eastern Box Turtle ■ *Terrapene c. carolina*

Box turtles are named for their ability to completely close their shell, protecting them against potential predators and desiccation.

Understanding Your Subject

Box turtles are a terrestrial turtle species facing decline across their North American range due to habitat loss, fragmentation, degradation, and collection for the exotic pet trade. They tend to be a solitary turtle, spending the majority of their time concealed within thick vegetation.

Locating Your Subject

Seasonally, box turtles use a mosaic of habitats including woodlands, wetlands, fields, and shrub lands. Box turtles are most

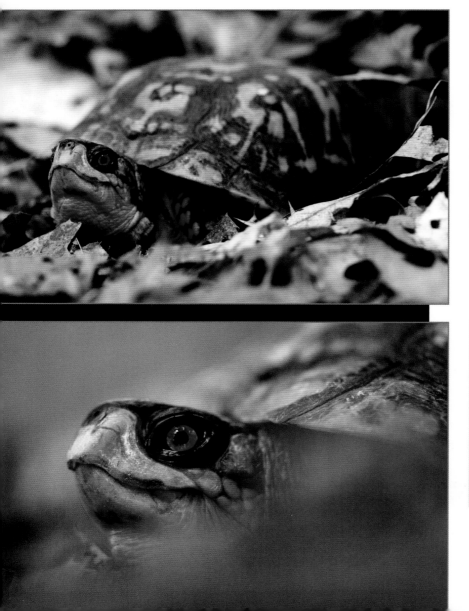

❝ When locating box turtles, spend time searching along habitat edges. ❞

In the Shade

When photographing in shaded conditions, increase your ISO to boost your camera's sensitivity to light. This will allow you to capture images in low-light environments.

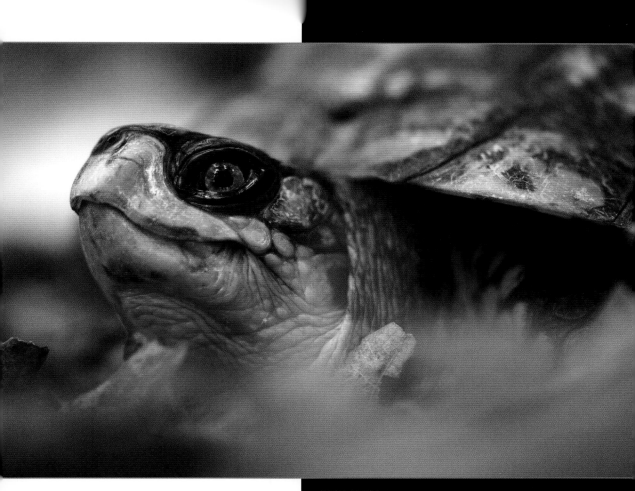

commonly encountered during the late spring and early summer months prior to being masked by thick vegetation. When locating box turtles, spend time searching along habitat edges—especially after rain events.

TECH SPECS ▲

- Nikon D7000 body
- Nikon AF-S VR Micro-Nikkor 105mm lens
- f/3.2 at 1/250 second, ISO 800
- Natural light conditions: sunny, shot in shade

Shooting Your Subject & Photographic Process

The image above was shot hand-held with the camera positioned at a distance of 1.8 feet and on a level plane with the turtle.

I was looking to capture the cryptic nature of box turtles. To do so, I used a shallow depth of field to create a softness over the entire animal, sharply contrasting with the small focal point of the subject's face.

Including muted colors in the foreground and background gave the image an overall moody feel, capturing a sense of reclusion. The dismal stare of the subject adds the perfect absence of emotion for this composition.

Working with box turtles can be tricky. They will often close themselves in their shells for long periods of time, only peeking their heads out slightly in curiosity.

43. Reflective Eyes

Eastern Garter Snake ■ *Thamnophis s. sirtalis*

L ike many species of snakes, garter snakes give live birth—to upwards of 50 young at a time.

Understanding Your Subject

Garter snakes are common across North America. They can be distinguished by their three longitudinal yellow stripes.

Locating Your Subject

Garter snakes occur in a variety of habitats and are often just as common in backyards as in natural areas. They prefer habitats in close proximity to water, such as moist meadows, wetlands, and woodlands. They are commonly active during the day, especially during the early morning and late evening.

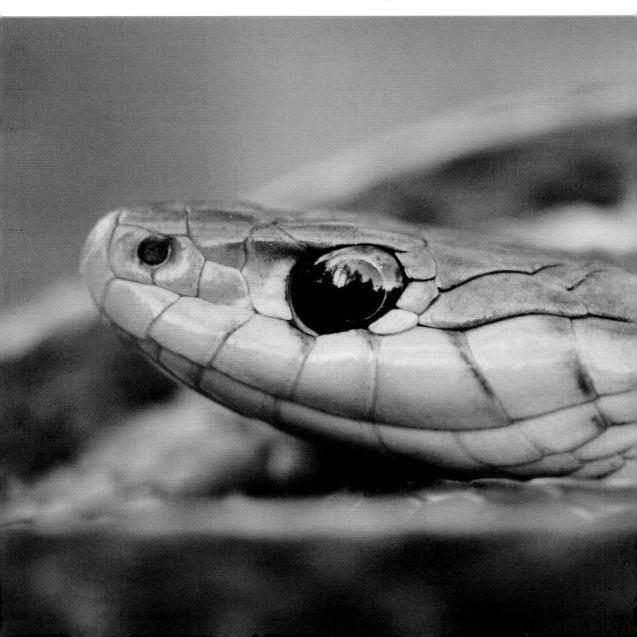

Shooting Your Subject & Photographic Process

This image was shot hand-held with the camera positioned at a distance of 1.3 feet and on a level plane with the subject.

Most diurnal species have large, dark rounded pupils which make them perfect for capturing eye reflections. This individual was located crawling around my backyard next to my koi pond, but I took the time to choose an appropriate staging area where the trees in the background would appear as reflections in the snake's eyes.

Photo Tip

A trick I use when staging snakes, is to gently cover the animal with my hands which seems to make them feel safe and secure. Once the snake stops moving around, I slowly lift my hands to uncover the snake, which will typically remain in coil, as seen below.

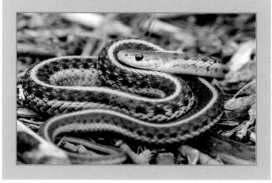

Capturing reflections can be challenging and requires a lot of cooperation from your subject. By experimenting with multiple staging areas and camera angles I was able to maximize the reflection in the final image (left), while eliminating the distracting reflection of the sun seen in the version below (see inset for a closer view of the reflection).

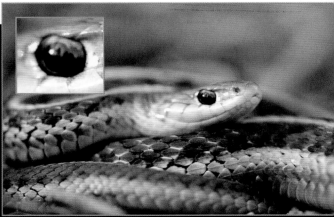

◄ **TECH SPECS**

- Nikon D7000 body
- Nikon AF-S VR Micro-Nikkor 105mm lens
- f/6.7 at 1/90 second, ISO 560
- Natural light conditions: sunny

44. Dangerous Close-Ups

Venomous Snakes ■ *Family Crotalinae*

Crotaline snakes have a unique thermo-detecting pit organ located midway between their eye and nostril. This allows them to detect the heat emitted by their warm-blooded prey.

Understanding Your Subject

Pit vipers are a large group of venomous snakes that can be found throughout the Americas, with commonly recognized species including the rattlesnake, water moccasin, and copperhead.

Locating Your Subject

Pit vipers are commonly encountered in a wide variety of climates and habitats across North America, from the desert southwest to the southern bayous, and north through the temperate forests of New England.

Shooting Your Subject & Photographic Process

The image on the facing page was shot from a tripod with the camera positioned at a distance of 3.6 feet and on an angle slightly above the subject. I wanted to capture the snake's beautiful blue eyes, as this is a rare color variant of the timber rattlesnake.

They are a dangerous subject to shoot but, for me, the beauty of these stoic animals is unrivaled. When photographing dangerous snakes, step back to leave plenty of room between yourself and the subject. Most snakes can strike a distance between $\frac{1}{3}$ to $\frac{1}{2}$ of their total body length. Many times,

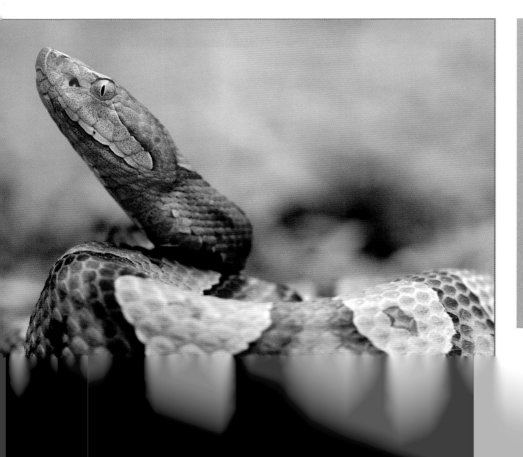

⚠ **CAUTION**
Venomous snakes should only be photographed when an experienced snake handler is present. Inexperienced individuals should never attempt to photograph venomous snakes alone.

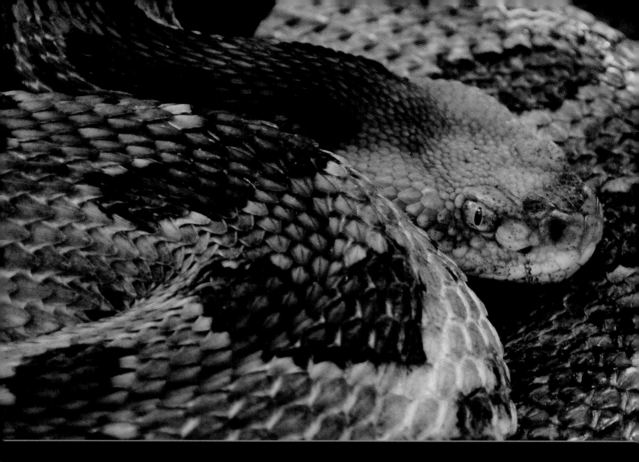

TECH SPECS ▲
- Nikon D7000 body
- Nikon AF-S VR Micro-Nikkor 105mm lens
- f/5.6 at 1/45 second, ISO 560
- Natural light conditions: overcast

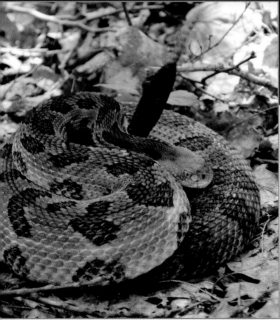

coiled snakes look far smaller than they actually are, so—again—step back.

From a safe distance, venomous snakes make surprisingly great photography subjects, as they tend to remain very still and are often not bothered by the presence of people. Because you must shoot these creatures from afar—even when using a macro lens—I often crop in the original composition (left) to obtain my final image (above).

45. A Little Luck

Gray Tree Frog ■ *Hyla versicolor*

Gray tree frogs start their life green in color, turning gray only as they mature.

Understanding Your Subject

Gray tree frogs, a type of arboreal frog, are experts at camouflage as both green juveniles and gray adults. Spending the majority of their time high in the canopy, gray tree frogs descend during the late spring to breed in wetland habitats.

Locating Your Subject

Gray tree frogs are most commonly encountered on warm, rainy nights when they can be seen hopping across roads. In the late summer, newly metamorphed juvenile frogs

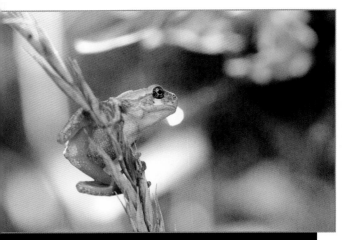

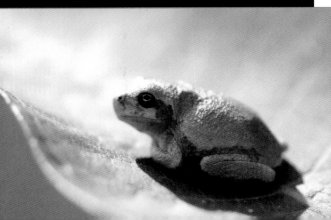

⚠ CAUTION

The skin of gray tree frogs is mildly toxic and will cause irritation if you touch them and then make contact with your eyes.

can be seen surrounding the natal wetland and taking refuge in the surrounding vegetation.

Shooting Your Subject & Photographic Process

The facing-page image was shot hand-held with the camera at a distance of 1.7 feet and on an angle slightly below the subject. I was working on a photography project for my amphibian and reptile identification web page, and was simply trying to document the color of a juvenile gray tree frog from multiple angles (left, top, and bottom). Imagine my surprise when this subject lunged off its leaf to capture a small fly. It happened so quickly, I literally did not have any time to react or adjust my camera settings. I was fortunate to capture the small froglet struggling with the fly as it hung upside down from the leaf. Normally, I would not display an image with such bright washed-out areas, but I'm forgiving of these details because this natural feeding display was such an incredible moment to capture.

TECH SPECS ▶

- Nikon D7000 body
- Nikon AF-S VR Micro-Nikkor 105mm lens
- f/3.3 at 1/1500 second, ISO 400
- Natural light conditions: sunny

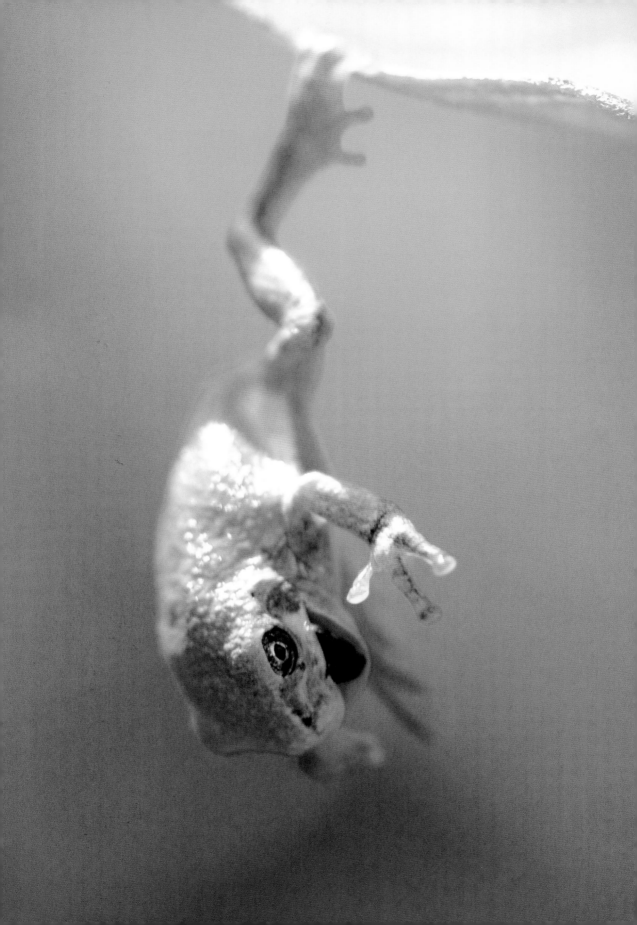

R ed efts are brightly colored to warn predators of their toxic skin secretions.

Understanding Your Subject

Eastern newts have a three-staged life cycle. They begin life as aquatic gilled larvae, then migrate to land for a few years as the juvenile terrestrial eft. Finally, they return to the

TECH SPECS ▶

- Nikon D7000 body
- Nikon AF-S VR Micro-Nikkor 105mm lens
- f/16 at 2 seconds, ISO 200
- Natural light conditions: overcast

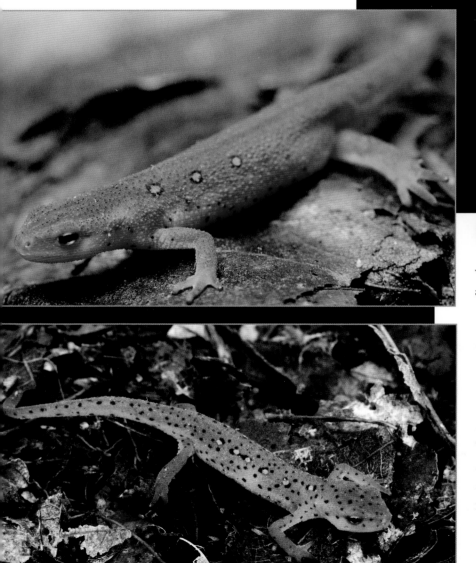

water where they remain as aquatic adults.

Locating Your Subject

Terrestrial red efts are common in woodlands and often seen walking along the forest floor during daylight hours. The best time to observe these newts is after a rainstorm when the forest floor is damp.

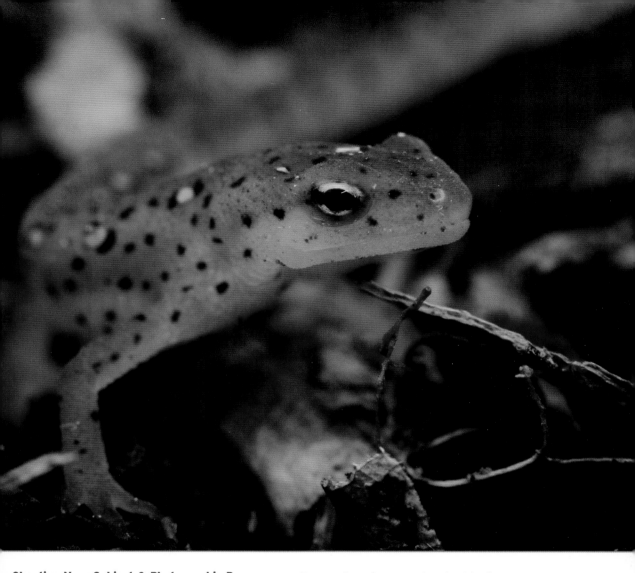

Shooting Your Subject & Photographic Process

In this photo series, I show the importance of camera positioning. Many times, photographers shoot from above when capturing small animals, making the subject appear inferior and vulnerable (facing page).

I prefer to shoot my subjects from an angle that is immersed in their world, essentially capturing the image from their point of view. Examine the contrast between the image above and those on the facing page. The image above is much more dynamic because it was captured from the newt's perspective.

It was shot from a tripod with the camera at a distance of 1 foot and on a level plane with the subject.

The lower camera angle can have a profound effect on how your audience views the subject, and may lead to a greater perception and appreciation of the organism because of the emotional connection made between the subject and viewer.

47. Lessons Learned

Eastern Spadefoot ■ *Scaphiopus holbrookii*

Spadefoots live a fossorial life, only surfacing under the cover of night to feed and reproduce.

Understanding Your Subject

Named for the distinctive spade-like projections located on their back feet (used for digging burrows), spadefoots are highly adapted to arid environments. Variable in color, they are covered in tiny tubercles (warts). The have large, bright yellow eyes and a lyre-shaped pattern on their back.

Locating Your Subject

Due to their fossorial habitat, spadefoots can be tricky to find. Using a variety of habitats with an affinity to sandy soils, including agricultural lands and forests, they are most commonly seen at night during heavy rain events. Explosive breeders, they can be observed reproducing en masse after heavy rains in temporarily ponded areas.

Shooting Your Subject & Photographic Process

This image was shot from a tripod with the camera positioned 1.5 feet away from the subject and on a level plane with it. My intent was to capture the beauty of the toad's bright yellow eyes.

I present these images as a learning experience for beginning photographers; they were taken in the infancy of my photography career, prior to even understanding my basic camera functions. Although these images work, their overall quality would have been drastically better had I done my homework. Their grainy appearance can be directly attributed to a high ISO of 2500 (when the lighting conditions certainly would have allowed for a much lower ISO in the 400 range). Because this subject remained relatively motionless, I would have been able to

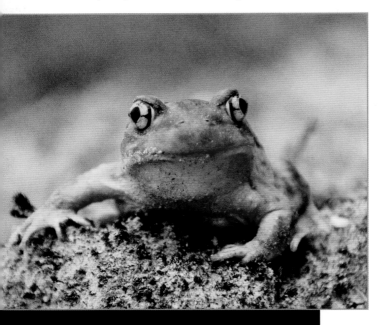

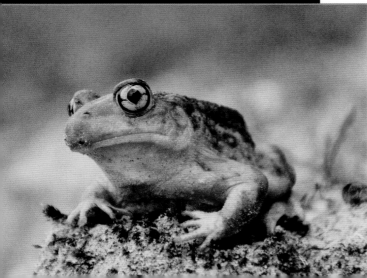

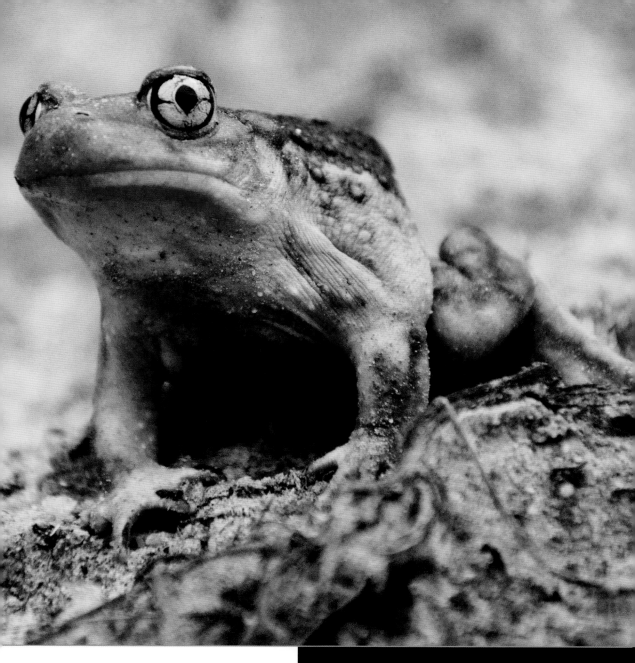

shoot at a much lower shutter speed, even $\frac{1}{60}$ or $\frac{1}{90}$ second, allowing me to increase my f-stop to capture more detail.

Each day, I continue to grow as a photographer, furthering my appreciation of the art and learning the importance of truly understanding the fundamental principles of photography.

TECH SPECS ▲

- Nikon D7000 body
- Nikon AF-S VR Micro-Nikkor 105mm lens
- f/5.6 at 1/5000 second, ISO 2500
- Natural light conditions: overcast

48. Capturing Flicking Tongues

Northern Black Racer ■ *Coluber c. constrictor*

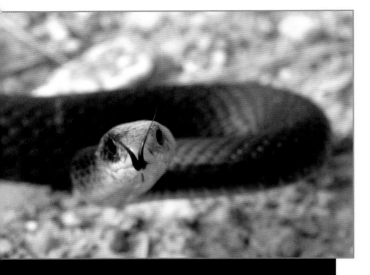

Northern black racers climb trees and shrubs when fleeing from potential predators. You may find that this behavior often works in your favor when shooting.

Understanding Your Subject

Various racer species occur across much of the United States. Racers are a large species of snake with the perfect personality to capture tongue-flicking. Often they will face off with the camera, posturing to defend themselves.

Locating Your Subject

Locating snakes is often not difficult. They inhabit a wide variety of habitats and are often seen basking in the early

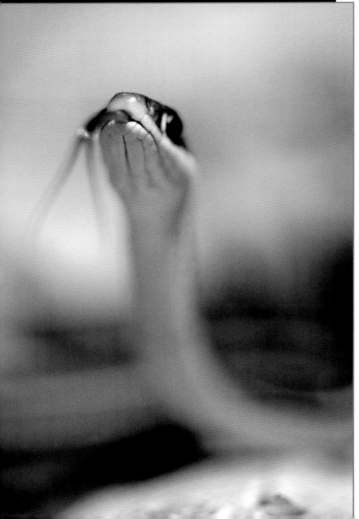

" When photographing flicking tongues, you will be close to your subject and should be prepared for the snake to defend itself. "

⚠ **CAUTION**

If you are not familiar with which snake species you are encountering, you should not attempt to photograph it at close range.

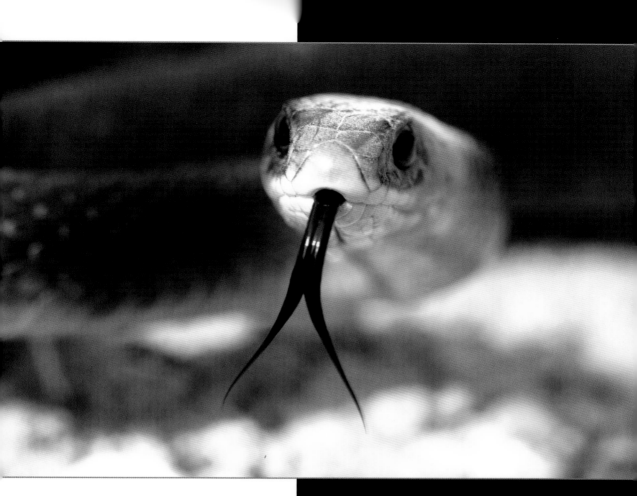

morning sun. Look along edges where two habitats meet, or along wetlands and in open sunny areas, to increase your likelihood of encountering snakes.

TECH SPECS ▲

- Nikon D7000 body
- Nikon AF-S VR Micro-Nikkor 105mm lens
- f/8 at 1/180 second, ISO 400
- Natural light conditions: sunny

Shooting Your Subject & Photographic Process

The image above was shot while lying on the ground, with the camera hand-held and positioned on a level plane with the subject at a distance of about 2.5 feet.

When photographing flicking tongues, you will be close to your subject and should be prepared for the snake to defend itself by biting. Although non-venomous snake bites are harmless, protect your eyes when shooting. In this image, the racer squared up to the camera, holding his defensive posture.

To capture the snake's tongue, I set my camera to f/8, shooting at a speed of $1/180$ second. You must use a fairly fast shutter speed to achieve crisp definition; slower shutter speeds do not typically capture the speedy action of a flicking tongue (facing page, bottom). The snake held its body still in its upright posture, and each time the tongue began to flick, I fired multiple shots. Eventually, I captured the final composition in the shot above.

49. Concealing the Subject

Pickerel Frog ■ *Lithobates palustris*

Pickerel frogs defend themselves against predators by emitting a toxic skin secretion, causing minor irritation and discomfort in humans when coming in contact with the eye.

Understanding Your Subject

Pickerel frogs are a medium-sized frog measuring 1.5 to 3 inches in length. They are often mistaken for leopard frogs but can be distinguished by their tan dorsum with darker brown squares arranged between two longitudinal cream-colored lines.

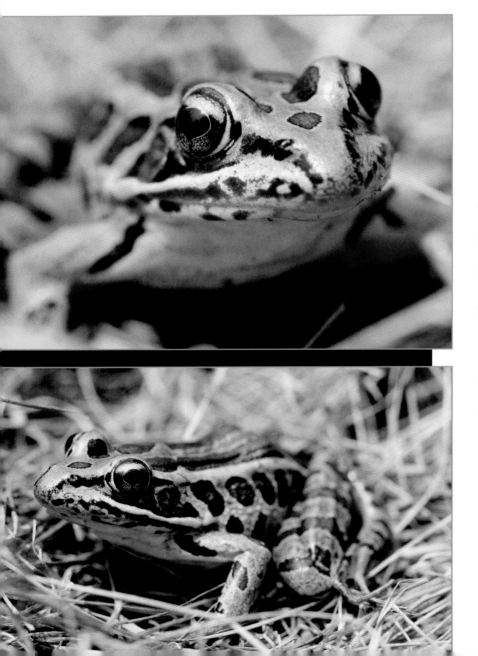

66 It was important for me to blur not only the background vegetation but also the subject – leaving a sense of mystery in the composition. 99

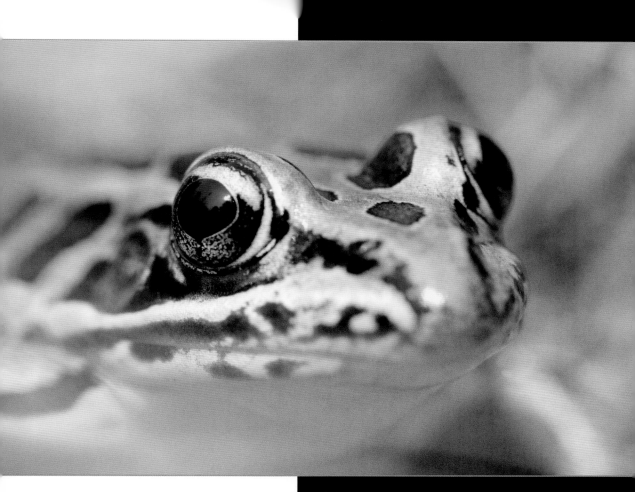

Locating Your Subject

Pickerel frogs occur in a variety of aquatic habitats and associated uplands. They are commonly encountered along open water edges, wet meadows, wooded swamps, and forested uplands.

Shooting Your Subject & Photographic Process

The image above was shot with the camera hand-held at a distance of 1.3 feet and on a level plane with the subject.

The background was achieved by staging the subject in a cluster of dried grass. Because the frog remained calm for the majority of the shoot, it rarely needed to be repositioned. I wanted to conceal my subject within the background, as it would naturally

TECH SPECS ▲

- Nikon D7000 body
- Nikon AF-S VR Micro-Nikkor 105mm lens
- f/6.7 at 1/90 second, ISO 800
- Natural light conditions: sunny

be seen in the wild, so I experimented with a variety of f-stops. I found that f/6.7 most closely captured the mood and composition I was going for.

It was important for me to blur not only the background vegetation but also the subject—leaving a sense of mystery in the composition. Showing only one eye, sharply focused, gives viewers a sense that this individual has remained undetected.

50. Subjects in Water

Bullfrog ■ *Lithobates catesbeianus*

The sex of an adult bullfrog can be determined by comparing the size of the tympanum (circular external ear) to the eye. The tympanum is much larger than the eye in males; in females, both are comparable in size.

▼ TECH SPECS

- Nikon D7000 body
- Nikon AF-S VR Micro-Nikkor 105mm lens
- f/6.7 at 1/90 second, ISO 400
- Natural light conditions: sunny

Understanding Your Subject

Bullfrogs are the largest of all North American frogs. Occurring in various shades of brown and green, they live a relatively solitary lifestyle.

Locating Your Subject

Bullfrogs have an affinity to water, living in close proximity to many aquatic habitats. They favor shorelines and muddy banks where they can hide amongst the vegetation as they wait in ambush of prey. Locating

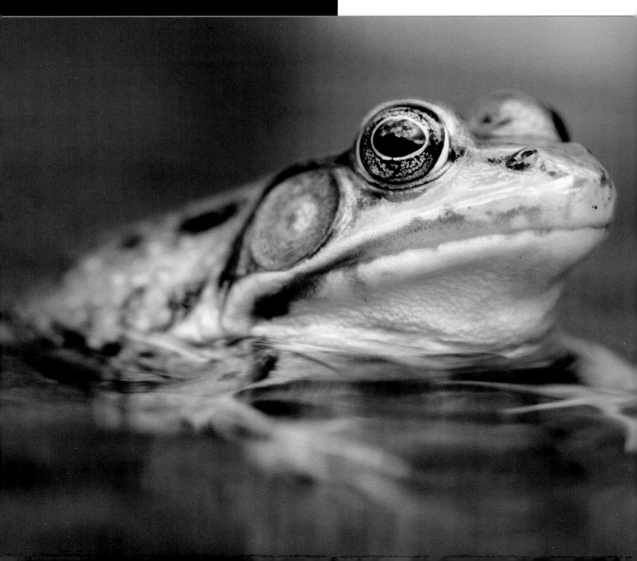

bullfrogs is easily done by walking along the water's edge.

Shooting Your Subject & Photographic Process

The large image below was shot hand-held. The camera was positioned 1.4 feet away from the subject and on a level plane with it.

For this image, I had to get a little wet, lying on my stomach in a slow-moving seepage area that led into a small pond. To capture my subject's aquatic environment and reduce the sun's glare, I needed to position the camera as close to the water as possible without submerging it.

I chose an aperture of f/6.7 to limit my depth of field because I wanted to direct the viewer's gaze to the beautiful sky reflecting in the subject's eye as the water softly flowed past. Species with large, dark pupils make perfect subjects to capture reflected skies.

This frog happened to be a very good model, but bullfrogs can often be very wary and apt to hop away, so have patience when shooting. It may take multiple tries to get a cooperative subject.

66 I needed to position the camera as close to the water as possible without submerging it. 99

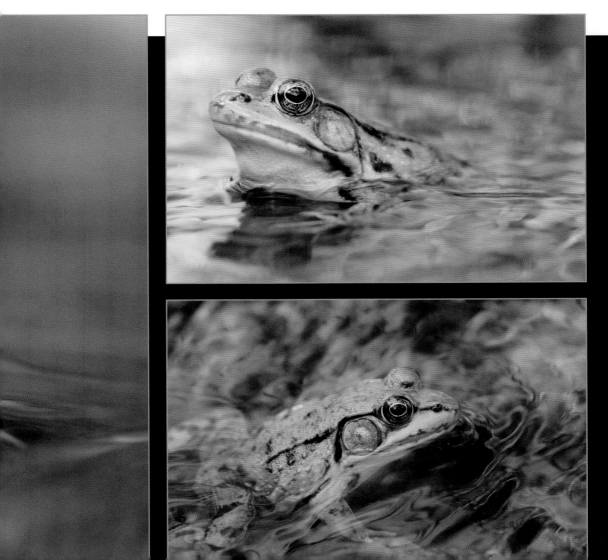

51. Shooting on Plexiglas

Red-Eared Slider ■ *Chrysemys scripta elegans*

Staging Area

For this setup I used a piece of Plexiglas with a white mat board positioned underneath it to serve as the reflective surface. Plexiglas was chosen because the weight and hard shell of this subject could have broken through glass and put the animal at risk of injury. The image background also consisted of a piece of white mat board.

Lighting

I used two 100W equivalent daylight (5000K) wet-rated outdoor and security LED spot light bulbs, mounted in basic reflective light fixtures. The first was positioned directly above the subject. The second was positioned in front of the subject and at a slight angle (see diagram).

Subject Manipulation

Turtles are often very easy subjects to work with in the studio. Many have distinct

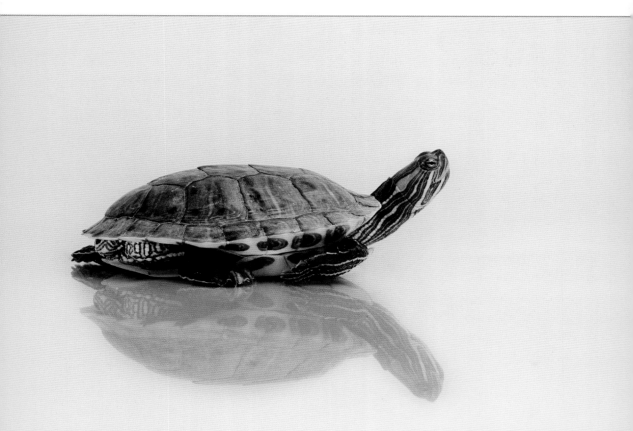

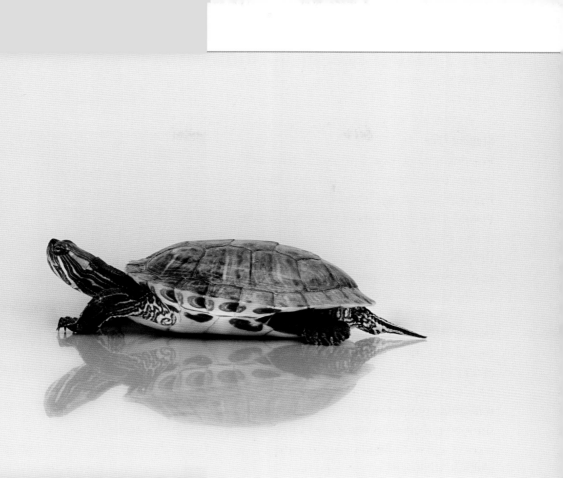

TECH SPECS ▲

- Nikon D7000 body
- Nikon AF-S VR Micro-Nikkor 105mm lens
- f/13 at 1/90 second, ISO 400
- Lighting: 2 100W-equivalent daylight (5000K) PAR38 dimmable LED flood light bulbs

personalities and are easily manipulated into desired poses.

To get your subject to interact with the camera, try gently touching the posterior end of the carapace (top shell). This often elicits a curious response and the turtle may outstretch its neck to look around. If your subject is timid at first, give it some time to settle in with the lights off. If you let turtles settle in from the get-go, once they do become active, they will often remain active for the entire shoot.

Shooting Your Subject & Photographic Process

These images were shot from a tripod with the camera positioned 3.3 feet away from the subject and on a level plane with it. I wanted to capture the turtle's beautiful profile, highlighting the characteristic red ear marking for which this species is named. The yellow markings on the turtle's limbs and shell further accentuate the image with beautiful splashes of color. The subtle reflection on the Plexiglas adds balance to complete the composition.

52. Photographing on Glass
Gray Tree Frog ■ *Hyla versicolor*

Staging Area
For this staging area, I propped up a small picture frame, leaving just the glass inside. I placed a black mat board about 12 inches behind the frame to serve as the background.

Lighting
I used two 100W equivalent daylight (5000K) wet-rated outdoor and security LED spot light bulbs, mounted in basic reflective light fixtures. One was directly above the subject; the other was below the subject and at a slight upward angle. Experiment with the light positioning until you are able to illuminate your subject without seeing a reflection of the lighting element itself.

Subject Manipulation
This shoot required little subject manipulation. To photograph the ventral side of the tree frog, I simply placed him on glass. This individual took very little time settling and remained completely still through most of the shoot.

Shooting Your Subject & Photographic Process
This image was shot from a tripod with the camera positioned on a level plane with the subject and at a distance of 1.7 feet. I chose to photograph through the glass to capture the characteristic toe pads, which help the tree frog adhere to flat surfaces. The frog's bright orange thighs also add a beautiful splash of color to the composition.

> ⚠ **CAUTION**
> The skin of many tree frogs is toxic, so be cautious not to make direct contact with your subject or rub your eyes during shooting. When handling amphibians, I wear latex gloves for both the animal's protection and mine.

❝ This individual took very little time settling and remained completely still through most of the shoot. ❞

TECH SPECS ▶
- Nikon D7000 body
- Nikon AF-S VR Micro-Nikkor 105mm lens
- f/3.3 at 1/45 second, ISO 400
- Lighting: 2 100W equivalent daylight (5000K) wet-rated outdoor and security LED spot light bulbs

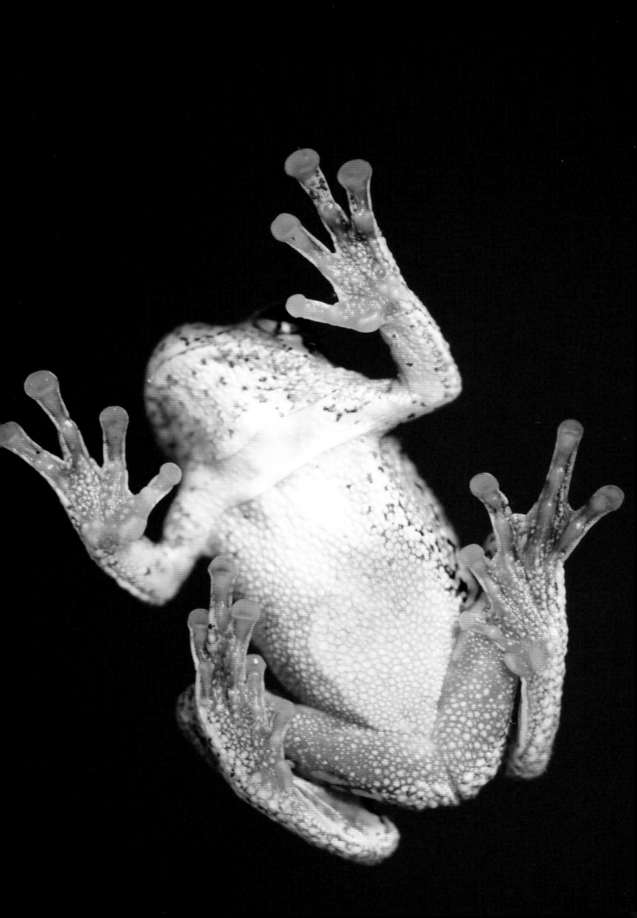

53. Capturing In-Studio Flight

Black Bee ■ Order *Hymenoptera*

Staging Area

My basic staging setup for capturing in-studio flight is a 1-gallon terrarium with a glass top. This allows plenty of room for the subject to move, but also keeps their flight localized in front of the camera lens. For these images, I placed a white mat board behind the terrarium to serve as the image background.

Lighting

A lot of light is required to freeze motion, so it was necessary to use three 100W

Photo Tip

Do not follow your subject around the tank. Instead, stay focused on one small area, timing your subject's flight path through your preset area of focus.

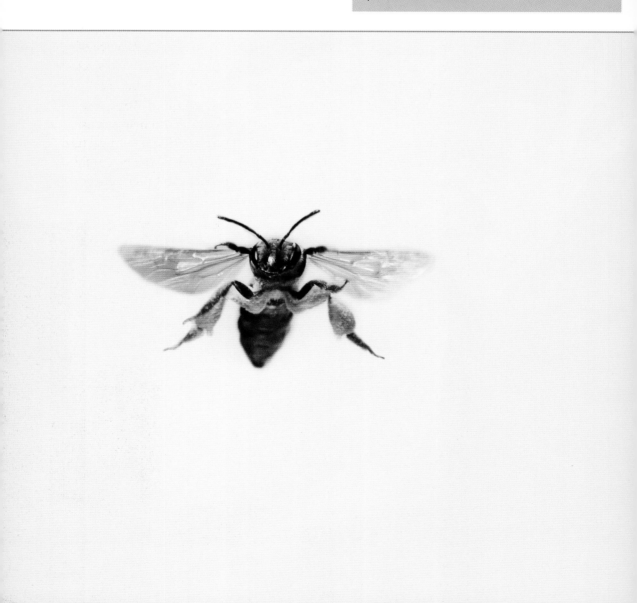

equivalent daylight (5000K) wet-rated outdoor and security LED spot light bulbs, mounted in basic reflective light fixtures. As you can see in the diagram below, two of the lights were positioned directly above the subject. The third light was positioned in front of the terrarium, shining upward at a slight angle.

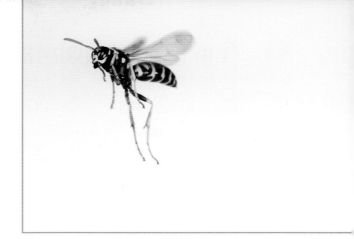

Subject Manipulation

No manipulation was required once the subject was inside the terrarium. Placing stinging insects into a terrarium is a bit tricky and one should always accept the fact that you may be stung. With that noted, I will capture the subject in a small glass jar with a lid that easily pops on and off. After placing the jar into the terrarium, I open the lid and secure the terrarium top, then wait for the subject to climb out of the jar at its own free will.

Shooting Your Subject & Photographic Process

The image to the left was shot from a tripod with the camera positioned at a distance of 2 feet and on a level plane with the subject. When shooting flight, you have limited control over the pose captured. To set my focus I used the tip of a pencil held against the outside of the terrarium glass. To capture the desired pose, I waited for the bee to fly within this point of focus and then simply shot frames in rapid succession.

◄ **TECH SPECS**

■ Nikon D7000 body

■ Nikon AF-S VR Micro-Nikkor 105mm lens

■ f/6.7 at 1/1500 second, ISO 400

■ Lighting: 3 100W equivalent daylight (5000K) wet-rated outdoor and security LED spot light bulbs

54. Staging Amphibian Larvae

Wood Frog ■ *Lithobates sylvaticus*

Staging Area

My basic aquatic staging setup for larval amphibians is a 1-gallon aquarium, which gives the subject enough room to move around while still remaining close to the camera lens. It is important to clean and disinfect the aquarium thoroughly prior to and in between subjects, ensuring the glass is free of blemishes and pathogens. Fill the aquarium with spring water. City tap water is treated with many chemicals and will have adverse health effects on your subject.

TECH SPECS ▼

- Nikon D7000 body
- Nikon AF-S VR Micro-Nikkor 105mm lens
- f/9.5 at 1/180 second, ISO 400
- Lighting: 1 100W equivalent daylight (5000K) wet-rated outdoor and security LED spot light bulb

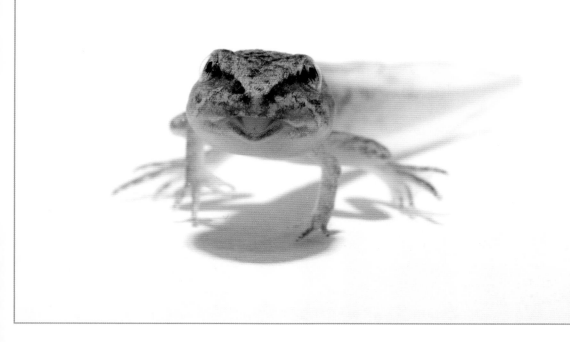

For fine art work, I prefer my subjects to be photographed against white. To obtain these results, use ceramic glass tiles upside down so the subject rests on the flat matte underside of the tile, eliminating reflections. I built a small 3x3x1.5-inch, three-sided glass tile structure that I placed inside the aquarium to photograph this subject in.

Lighting

For the shot on the facing page, I used one 100W equivalent daylight (5000K) wet-rated outdoor and security LED spot light bulb, mounted in a basic reflective light fixture directly above the subject. I use LED lighting for wildlife applications because these lights produce the desired white light and very little heat.

Subject Manipulation

When subjects are in undesirable poses, reposition them using the blunt end of a disposable bamboo skewer. Gently brush

> ⚠ **CAUTION**
> Never contact amphibians directly with your hands. They are very susceptible to environmental toxins and will absorb them directly through their skin.

their posterior end until the desired position is obtained. Never use your hands to reposition your subject as this often invokes a stress responses in the organism.

Shooting Your Subject & Photographic Process

The facing-page image was shot from a tripod with the camera positioned at a distance of 1.2 feet and on a level plane with the subject. Shooting the subject head-on and at f/9.5, I was able to capture the intricate details in pattern and color while fading the tail into the background. The lighting from above cast the shadow directly below the subject, eliminating distraction.

55. Incorporating Water Droplets

Harlequin Ladybird ■ *Harmonia axyridis*

Staging Area

This composition was staged on a mirror. A white mat board was positioned in the background to reflect back onto the mirror's surface. Complementing the circular theme of my subject, I added three

TECH SPECS ▼

- Nikon D7000 body
- Nikon AF-S VR Micro-Nikkor 105mm lens
- f/11 at 1/250 second, ISO 400
- Lighting: 2 100W equivalent daylight (5000K) wet-rated outdoor and security LED spot light bulbs

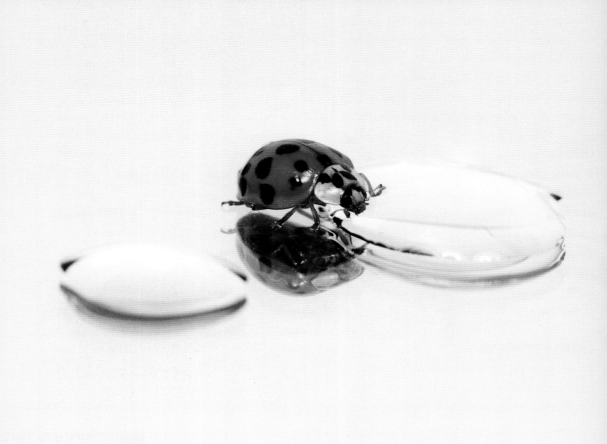

droplets of water in varying sizes to add dimension.

Lighting

I used two 100W equivalent daylight (5000K) wet-rated outdoor and security LED spot light bulbs, mounted in basic reflective light fixtures. These were positioned pointing slightly downward on either side of the subject.

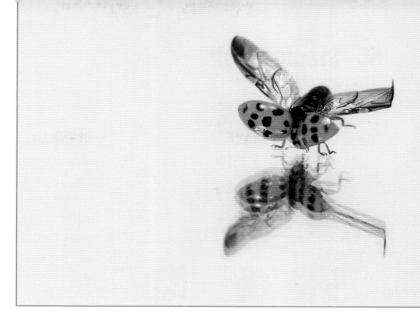

Subject Manipulation

I did not need to manipulate this subject; as soon as I put the ladybird on the mirror, it walked over to the middle droplet and used the water tension to position itself slightly on top.

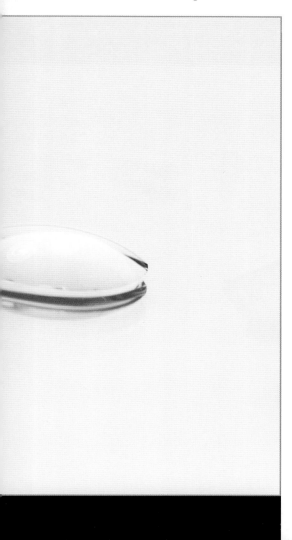

Shooting Your Subject & Photographic Process

This image was shot from a tripod with the camera positioned at a distance of 1.3 feet and on a slight angle above the subject. This angle allowed me to take full advantage of the ladybird's position atop the droplet, capturing the reflection of its ventral surface in the mirror.

> ❝ As soon as I put the ladybird on the mirror, it walked over to the middle droplet . . . ❞

Photo Tip

Photographers often refrigerate their subjects, cooling them to slow them down for easier manipulation in staged images. I do not use this technique. Instead, I rely on patience and the animal's natural instincts to position itself.

56. Staging Fish
Siamese Fighting Fish ■ *Betta splendens*

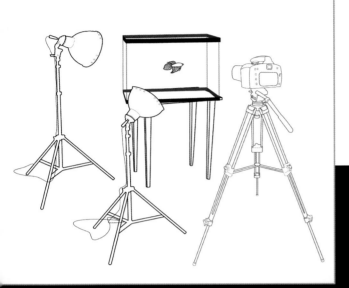

Staging Area

My basic aquatic staging setup for fish is a 1-gallon aquarium, which gives the subject enough room to move around while still remaining close to the camera lens. Make sure to fill the aquarium only with spring water; city tap water is treated with many chemicals and will have adverse health effects on your

TECH SPECS ▼
- Nikon D7000 body
- Nikon AF-S VR Micro-Nikkor 105mm lens
- f/8 at 1/125 second, ISO 400
- Lighting: 2 100W equivalent daylight (5000K) wet-rated outdoor and security LED spot light bulbs

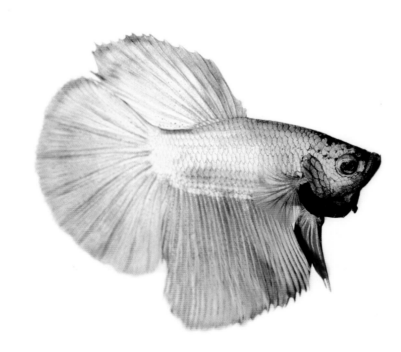

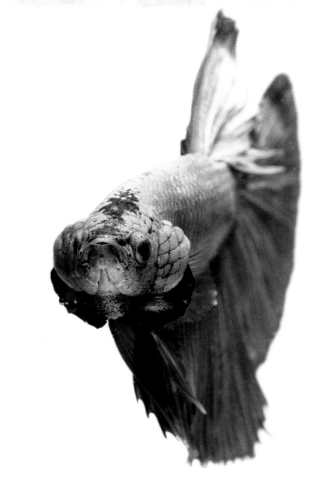

subject. Alternately, you can also treat your water with a conditioner available at your local pet shop.

A white mat board positioned approximately 12 inches behind the aquarium served as the image background.

Lighting

For the facing-page shot, I used two 100W equivalent daylight (5000K) wet-rated outdoor and security LED spot light bulbs, mounted in basic reflective light fixtures. I angled one into the tank from the side and the other I positioned in front of the aquarium at a slight offset (see diagram).

Subject Manipulation

This subject was indirectly manipulated into position by placing one pellet of food into the aquarium. This facilitated my ability to establish a fixed field of focus around the food item, capturing the subject as it swam around the food particle during feeding.

Shooting Your Subject & Photographic Process

The image was shot from a tripod with the camera at a distance of 2 feet and on a level plane with the subject. Capturing the desired pose with the fins fully extended—especially the red pelvic fins—was challenging and took patience and time.

57. Staging Natural Environments

Damselfly Larvae ■ Suborder *Zygoptera*

Staging Area

When staging either aquatic or terrestrial species, my rule of thumb is to keep it simple. On a macro level, detailed staging areas typically complicate and clutter the image.

When choosing how to stage your subject, look to their environment and try to use substrates, plants, or materials that you would likely find your subject interacting with naturally. Here, I illustrated two examples of natural staging areas, the first being aquatic and second being terrestrial.

For the terrestrial setup (top right), I simply used partially decomposed leaf litter from a wetland. Building the leaves up in the back allowed me to use them for dual purposes: as both a background and substrate. This type of staging area would serve perfectly for amphibians that naturally occur in forested wetlands. For the aquatic staging area (below and facing page), I used a piece of submergent vegetation found in the same wetland as the subject.

Lighting

I used one 100W equivalent daylight (5000K) wet-rated outdoor and security LED spot light bulb, mounted in a basic reflective light fixture 12 inches directly above the subject.

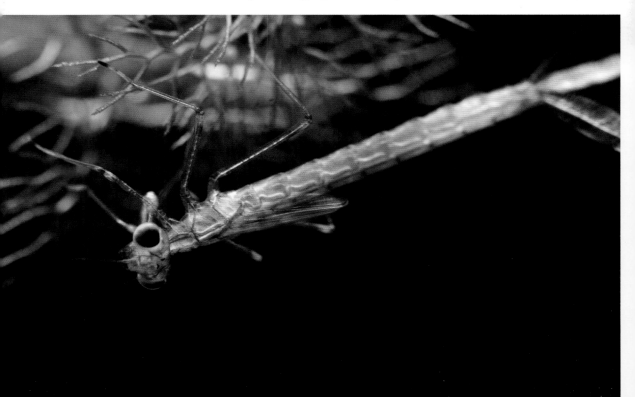

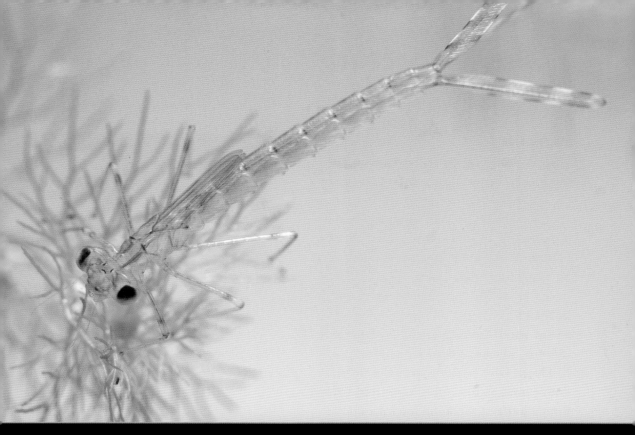

TECH SPECS ▲

- Nikon D7000 body
- Nikon AF-S VR Micro-Nikkor 105mm lens
- f/9.5 at 1/250 second, ISO 400
- Lighting: 1 100W equivalent daylight (5000K) wet-rated outdoor and security LED spot light bulb

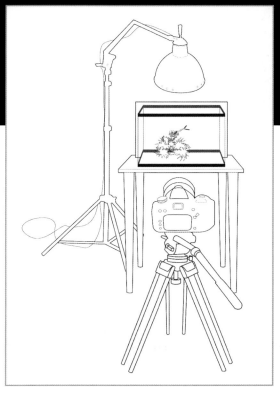

Subject Manipulation

No subject manipulation was necessary for this shoot. The damselfly felt at home on the vegetation and slowly moved around, positioning itself for the shoot.

Shooting Your Subject & Photographic Process

The image above was shot from a tripod with the camera positioned at a distance of 1.1 feet and on a level plane with the subject. Due to the subject's positioning on the plant, however, it appears to have been shot from above.

58. Staging Around Your Subject

Mosquito ■ Family *Culicidae*

Staging Area

No special staging area was designed for this image. Instead, the mosquito landed on the wall next to where I was set up to shoot another subject. To take advantage of this opportunity, I simply moved one light behind the subject and used the wall it landed on as my backdrop.

Lighting

I used one 100W equivalent daylight (5000K) wet-rated outdoor and security LED spot light bulb, mounted in a basic reflective light fixture. This was placed behind the subject at a slight downward angle.

Subject Manipulation

No subject manipulation was necessary. Instead, this shoot was staged around the subject's natural landing position. Trying to manipulate such a small subject would likely cause damage to its delicate structures.

Shooting Your Subject & Photographic Process

This image was shot hand-held with the camera positioned at a distance of 1.1 feet and on an angle slightly below the subject. I eliminated the potential for distracting shadows by lighting the mosquito from behind, casting the shadow directly below the subject.

Mosquitoes are not often thought of as beautiful subjects, but under the macro lens their intricate details are illuminated. Adding to the interest of this subject is her fully engorged, blood-filled abdomen.

TECH SPECS ►

■ Nikon D7000 body
■ Nikon AF-S VR Micro-Nikkor 105mm lens
■ f/11 at 1/350 second, ISO 400
■ 1 100W equivalent daylight (5000K) wet-rated outdoor and security LED spot light bulb

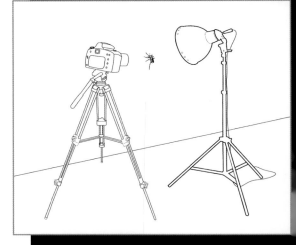

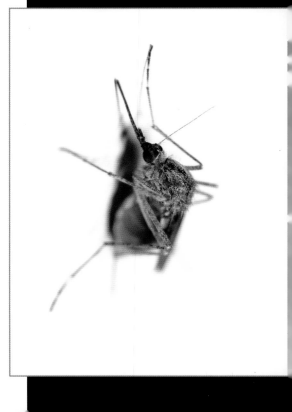

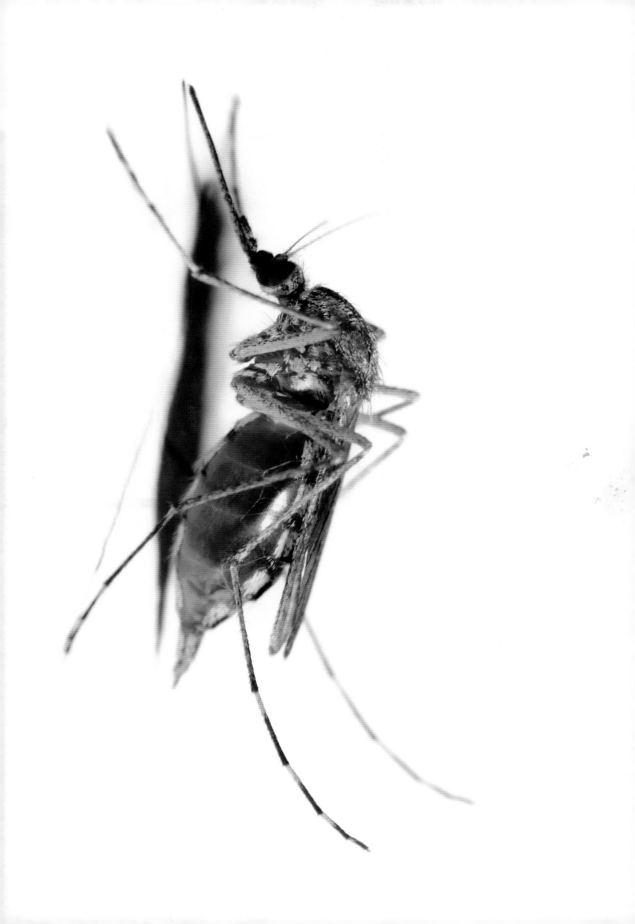

59. Reflective Black Surfaces

Tiger Salamander ■ *Ambystoma tigrinum*

Staging Area

Glass and mirrors work best when staging reflective images. In this example, the subject rests on a piece of glass layered atop black mat board. Glass creates a ghostly reflection instead of the sharp reflection obtained with mirrors. Additionally, shooting on glass allows you to devise creative colors and textures simply by layering different substrates underneath the reflective surface.

Lighting

I used two 100W equivalent daylight (5000K) wet-rated outdoor and security LED spot light bulbs, mounted in a basic reflective light fixture. One was fixed on the subject and the other was directed toward the background.

Subject Manipulation

When staging living subjects, it is imperative to keep the poses natural. Prior to posing and lighting this tiger salamander, I allowed time for it to sit and become comfortable within the staging area. By gently manipulating the animal with a bamboo stick, I positioned the tail in a curving line back toward the camera. To coax the head into an upright position, I used the same bamboo stick and placed it underneath the animal's chin, gently applying upward pressure.

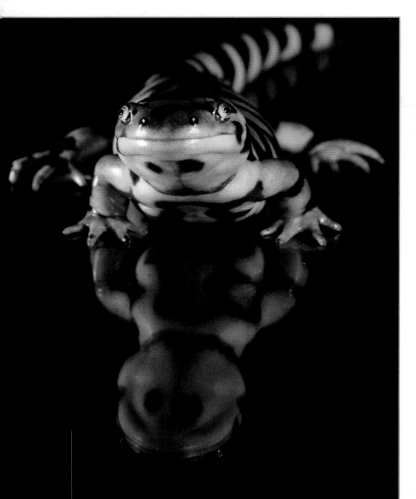

Shooting Your Subject & Photographic Process

This image was shot from a tripod with the camera at a distance of 2.3 feet and on an angle slightly above the subject. The combined positions of the camera and lights allowed me to capture the ghostly reflection while also reducing skin glare.

❝ I positioned the tail in a curving line back toward the camera. ❞

Photo Tip

The safety and well being of your subject should always be a bigger priority than "getting the shot." Never subject animals to potentially harmful situations and keep photo session times short (10 to 15 minutes) to reduce the stress on your subject.

TECH SPECS ▼

- Nikon D7000 body
- Nikon AF-S VR Micro-Nikkor 105mm lens
- f/11 at 1/45 second, ISO 400
- Lighting: 2 100W equivalent daylight (5000K) wet-rated outdoor and security LED spot light bulbs

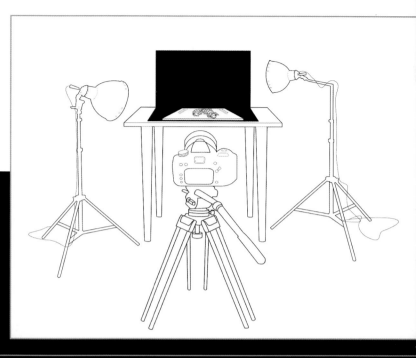

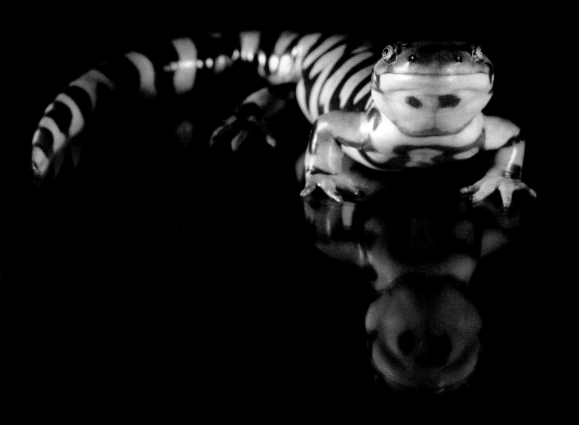

60. Staging Multiple Subjects

Goldenrod Soldier Beetle ■ *Chauliognathus pensylvanicus*

Staging Area & Lighting

I laid down multiple tightly-bunched clusters of bedstraw flowers and used a white mat board to serve as the backdrop.

I used two 100W equivalent daylight (5000K) wet-rated outdoor and security LED spot light bulbs, mounted in basic reflective light fixtures. These were placed 12 inches on either side of the subjects.

Subject Manipulation

No direct manipulation was necessary when the subjects were climbing around on the bedstraw flowers. However, soldier beetles do have a tendency to fly "off set" quite frequently. When the beetles took to flight, I simply watched where they landed and placed a small glass jar over them. To keep them in the jar, I slid a playing card between the landing surface and jar opening. I then released them back onto the bedstraw flowers with a simple tap to the back of the glass.

Shooting Your Subject & Photographic Process

The goal of the image on the facing page was to capture two individuals interacting with each other to add an interest and dynamism—a quality that was missing in the initial shot (below).

⚠ CAUTION

When staging multiple individuals, be sure to monitor their integrations closely. Putting together individuals that would otherwise avoid contact can lead to aggressive integrations. If this occurs, the subjects should be separated immediately—before continuing the shoot.

As these subjects curiously moved around each other, I set my aperture to f/4.8, limiting my depth of field and softening the white flowers and green stems in the background. By firing my camera continuously as the beetles moved about, I was able to capture a beautiful pose as one came up from underneath the other, pausing briefly before continuing on his own way.

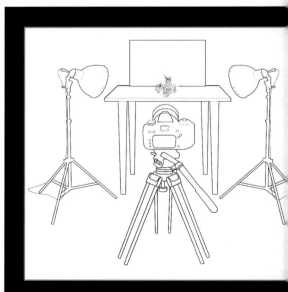

TECH SPECS ▶

- Nikon D7000 body
- Nikon AF-S VR Micro-Nikkor 105mm lens
- f/4.8 at 1/90 second, ISO 400
- Lighting: 2 100W equivalent daylight (5000K) wet-rated outdoor and security LED spot light bulbs

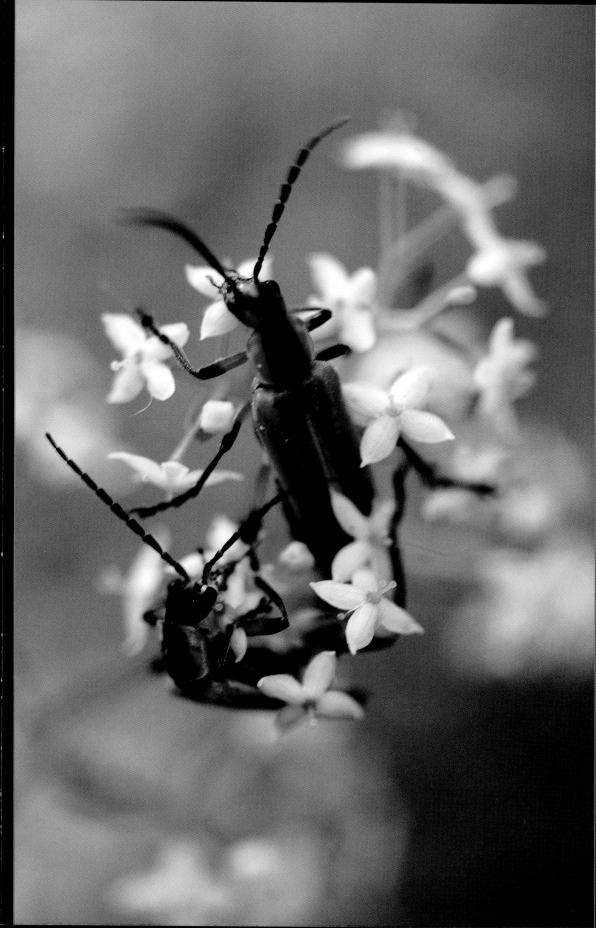

Bibliography

Evans, Arthur V. *Beetles of Eastern North America.* (Princeton University Press, 2014)

Grace, Carol. *Spring Wildflowers of the Northeast: A Natural History.* (Princeton University Press, 2012)

Wagner, David L. *Caterpillars of Eastern North America.* (Princeton University Press, 2005)

Hammerson, Geoffrey A. *Connecticut Wildlife: Biodiversity, Natural History, and Conservation.* (University Press of New England, 2004)

Han, M.H.; Park, C.; Jin, C.-Y.; Kim, G.-Y.; Chang, Y.-C.; Moon, S.-K.; Kim, W.-J.; Choi, Y.H. "Apoptosis Induction of Human Bladder Cancer Cells by Sanguinarine through Reactive Oxygen Species-Mediated Up-Regulation of Early Growth Response Gene-1." *PLOS ONE.* May 22, 2013 (http://journals.plos.org/plosone/article?id=10.1371/journal.pone.0063425)

O'Donnel, Jane E.; Gall, F. Lawrence; Wagner, L. David. *The Connecticut Butterfly Atlas.* (State Geological and Natural History Survey. Bulletin No. 118, 2007)

Newcomb, Lawrence. *Newcomb's Wildflower Guide.* (Little, Brown and Company, 1977)

Klemens, Michael W. *Amphibians and Reptiles of Connecticut and Adjacent Regions.* (State Geological and Natural History Survey. Bulletin No. 112, 1993)

Internet Resources

www.arkive.org
www.bugguide.net
www.ct-botanical-society.org
www.eddmaps.org
www.efloras.org
www.entnemdept.ufl.edu
www.fda.gov
www.illinoiswildflowers.info
www.magicicada.org
www.plants.usda.gov
www.webmd.com
www.wildflower.org
www.uwm.edu/fieldstation/naturalhistory/bugoftheweek/

Index

F

Feeding, 35, 40, 42–43, 50–51, 55, 94–95
Fish, 116–17
Focus, 44–45, 55, 110–11, 116–17
Food, 116–17
Flight, 13, 22–23, 44–45, 110–11
Flowers, positioning, 70–71
Fly, 12, 40–41, 42–43, 46–47
Forget-me-not, 58–59
Frog, 94–95, 98–99, 102–3, 104–5, 108–9, 112–13

G

Garter snake, 90–91
Geranium, 80–81
Glare, 39
Glass, 108–9
Goldenrod, 6, 22
Grasshopper, 35, 48–49
Gray tree frog, 94–95, 108–9
Great spangled fritillary, 54–55

H

Harlequin ladybird, 114–15
Hatchling, 86–87
Herb Robert, 62–63
Hickory tree, 26
Hickory tussocks caterpillar, 26–27
Hive, 44–45
Housefly, 12, 40–41
Hypo-pharynx, 42–43

I

ISO setting, 48, 88–89, 98–99

J

Japanese Beetle, 12–13
Joe-pye weed, 6–7
Jumping spider, 28–29

K

Knapweed, 55

L

Labellum, 74–75
Ladybird, 114–15
Larvae, 20, 37, 118–19
Lenticular button, 33
Lighting, studio, 106–25
Leopard frog, 102–3
Looper caterpillar, 27

M

Mantis, 34–35
Mat board, 59, 68, 122, 124–25
Mayfly, 30–31

Milkweed, 18, 54–55
Mirror, 114–15
Mosquito, 120–21
Moth, 50–51
Motion blur, 11, 13, 22, 25, 44–45, 74, 84–85, 98–99, 100–101
Multiple subjects, 6–7, 14–15, 26–27, 48–49, 124–25

N

Naiad, 16–17, 30
Newt, 96–97
Nightshade, 76–77
Northern black racer, 100–101
Nymph, 6, 10

O

Orchid, 74–75
Oriental beetle, 12–13
Oxeye daisy, 64–65

P

Pandorus sphinx caterpillar, 32–33
Parasitoid, 46–47
Pickerel frog, 102–3
Pink lady's slipper, 74–75
Pit viper, 52–53
Plexiglas, 106–7
Plume moth, 50–51
Posing. See Staging subjects
Praying mantis, 34–35
Proboscis, 46–47, 51
Pronotum, 52–53

Q

Queen Anne's Lace, 6

R

Raceme, 60–61, 70–71
Racer, 100–101
Rainbow Scarab, 12–13
Rattlesnake, 52–53
Red-eared slider, 106–7
Refrigeration, 115
Respect for subjects, 14–15, 28, 52–53, 86–87, 112–13, 115, 123, 124–25
Robber fly, 42–43
Rosette grass, 66–67
Round-lobed hepatica, 68–69
Rubus, 21

S

Saddleback caterpillar, 36–37
Safety, 10, 18, 25, 28, 37, 76–77, 52–53, 94–95, 100–101, 102–3, 108, 110–11, 113
Salamander, 122–23

Scarab beetles, 12–13
Shutter speed selection, 11, 13, 23, 25, 44–45, 49, 74, 98–99, 100–101
Siamese fighting fish, 116–17
Siberian squill, 70–71
Snake, 90–91, 52–53, 100–101
Snowdrop, 72–73
Soldier beetle, 22–23
Spadefoot, 98–99
Spider, 24–25, 28–29
Spinneret, 24
Spotted cucumber beetle, 38–39
Staging subjects, 52–53, 58–59, 91, 118–19
Stamen, 80–81
Staminode, 74–75
Studio lighting, 106–25
Sweat bee, 44–45
Swimming, 116–17

T

Tegmina, 48
Terrarium, 110–11
Terrestrial eft, 96–97
Thistle, 54–55
Tiger salamander, 122–23
Timber rattlesnake, 52–53
Tree frog, 94–95, 108–9
Tripod, 12, 17, 20–21, 25, 29, 31, 37, 40, 43, 48–49, 50–51, 52–53, 59, 66, 74, 76, 97, 107, 108, 111, 115, 116–17, 119, 122
Turtle, 86–87, 88–89, 106–7
Tympanum, 104–5

U

Umbel, 80–81

V

Violet, 54–55

W

Walnut tree, 26
Water, 30–31, 114-15
Water moccasin, 52–53
Webs, 24–25, 29
Whorl, 84–85
Wild geranium, 80–81
Wood anemone, 84–85
Wood frog, 112–13

Y

Yarrow, 46–47

Get smarter from a book!

AmherstMedia.com

- ■ *New books every month*
- ■ *Books on all photography subjects and specialties*
- ■ *Learn from leading experts in every field*
- ■ *Buy with Amazon, Barnes & Noble, and Indiebound links*

The Complete Guide to Bird Photography

Jeffrey Rich shows you how to choose gear, get close, and capture the perfect moment. A must for bird lovers! $37.95 list, 7x10, 128p, 294 color images, index, order no. 2090.

Shoot Macro

Stan Sholik teaches you how to show tiny subjects to best effect. Includes tips for managing lighting challenges, using filters, and more. $27.95 list, 7.5x10, 128p, 180 color images, order no. 2028.

Master Low Light Photography

Heather Hummel takes a dusk-to-dawn tour of photo techniques and shows how to make natural scenes come to life. $37.95 list, 7x10, 128p, 180 color images, index, order no. 2095.

Tiny Worlds

Create macro photography that bursts with color and detail. Charles Needle's approach will open new doors for creative exploration. $27.95 list, 7.5x10, 128p, 200 color images, order no. 2045.

Black & White Artistry

Chuck Kimmerle shares some of his most evocative images and teaches you his creative approach to re-envisioning places and spaces. $37.95 list, 7x10, 128p, 205 color images, index, order no. 2076.

The iPhone Photographer

Michael Fagans shows how the iPhone's simple controls can push you toward greater creativity and artistic expression. $27.95 list, 7.5x10, 128p, 300 images, order no. 2052.

Wildlife Photography

Joe Classen teaches you advanced techniques for tracking elusive images and capturing magical moments in the wild. $34.95 list, 7.5x10, 128p, 200 color images, order no. 2066.

Magic Light and the Dynamic Landscape

Jeanine Leech helps you produce more engaging and beautiful images of the natural world. $27.95 list, 7.5x10, 128p, 300 color images, order no. 2022.

Digital Black & White Landscape Photography

Trek along with Gary Wagner through remote forests and urban jungles to design and print powerful images. $34.95 list, 7.5x10, 128p, 180 color images, order no. 2062.

Shoot to Thrill

Acclaimed photographer Michael Mowbray shows how speedlights can rise to any photographic challenge—in the studio or on location. $27.95 list, 7.5x10, 128p, 220 color images, order no. 2011.